T0079779

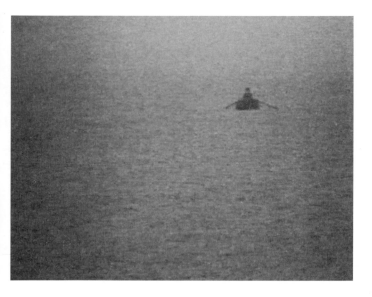

Marina rowed a boat straight towards the horizon.
There was sound recording equipment in the boat.
Ulay stood on the shore, receiving the sound through
headphones while the boat disappeared over the horizon.

A book by Jeannette Fischer

For Marina

Psychoanalyst meets Marina Abramović

Artist meets Jeannette Fischer

Foreword 8

# Pain gives feeling to fear 13

Fear 14
Guilt and punishment 40
Alone 64

# Since the world's been round, there's been no edge to fall off 75

The umbrella 76
Mission Impossible 84
Power over violence 89

## Impotence knows no bounds     95

Disregard     96
No     101
Fear and impotence turn to pain     109

## Reliable rejection     117

Envy     118
Doorknob     138

## Buttering people up doesn't still their hunger     145

Love     146
0 : 1     156
Lonely     160

# Foreword

Marina and I met at her house in Hudson in August 2015. We wired ourselves up with microphones and spent four days together. Those recordings form the basis of this book. Our conversation advanced through free association, the only goal being, as Marina put it: "From my point of view you're making a book for me, to clarify my soul. There's something I'd like to understand better. Explain the links between my work and my life to me. What do I take from my personal life and transform into work, into art? I'd like greater clarity about that."

We laughed a lot, then things turned serious. It was continually exciting and fruitful for both of us.

We first met in 1998. I saw her exhibition Artist Body—Public Body at the Kunsthalle in Berne. Her performances reveal all the fine and subtle relationship structures between people, the hierarchical

distinctions, the mechanisms of the violence that inevitably exists below the surface and that generally go unnamed. It occurred to me that she performs the same things that I explore through psychoanalysis. I was very impressed and immediately rang her up. That was the start of our friendship. Our interest in each other's work gave rise to a deep trust in each other and in our relationship.

This book contains selected extracts from our conversations in Hudson, meshed together with statements by Marina and my comments from our joint process over those four days. Marina said, "I have no idea what course our conversation will take. What interests me is that Jeannette understands more about my mechanism than I do myself. The older I get the more clearly I see my patterns and repetitions: the same situation, different people, the same reaction."

At the end of each train of thought, I've inserted a phrase, the first half of which recurs throughout the book, highlighted in green:

This is what Marina Abramović's performance is about.

After the colon I make a condensed statement about the unconscious and conscious elements I recognize in her performances. Marina uses all her might to

channel prodigious internal and external forces and power relations into art. We were able to get to grips with these during our conversations in Hudson, and recognize and understand them. That was how this book came into being, and that is what it's about.

I selected four performances from Marina's extensive body of work to which I refer regularly throughout the book.

*Untitled, 1970 Belgrade (unperformed idea)*
*Rhythm 0, 1974 Naples*
*Incision, 1978 Graz*
*The Artist is Present, 2010 MoMA, New York*

I had to make a selection, and the merciless, inescapable nature of these four made such an impact on me that I couldn't leave them out.

I have also quoted remarks by Ulay (Marina's first partner) and Klaus Biesenbach (director of MoMA) from the film *The Artist is Present*. The film was released in 2012 to mark Marina's ninety-day performance and exhibition of the same name at MoMA, and it won six awards.

I would like to thank Marina for her enormous trust over the many years of our friendship and also for her generosity and hospitality. I am delighted that we have been able to work on this book together.

My thanks also to Jacqueline Schöb, who has been a reliable, reassuring and supportive friend to me. She and Vera Reifler designed the book and did the layout of the text. Brigitte Brunner read my draft and alerted me to repetitions, ambiguities and inconsistencies. Erica Meier, an experienced psychoanalyst, ran a critical eye over my text. Marc Philip Seidel accompanied me to the conversations in Hudson. He managed the technical aspects and took the photos on the cover. Marie Kauffmann transcribed and translated our conversations. Mirjam Baitsch travelled with me to New York and noted the corrections as Marina and I discussed the manuscript. Bernhard Wenger edited the text with enormous care and sensitivity. Simon Pare translated the book into English with great sympathy and rigour.

This book would not have been possible without the help of all these people, and I am extremely grateful to them.

Pain gives feeling
to fear

# Fear

JF      Pain is a constant feature of all your performances. It is ubiquitous—ubiquitous in its silence and its conceal-ment. What is this pain that keeps repeating itself and that you always carry inside you?

MA      There are different types of pain. The pain changes. At the moment it is in the process of leaving me. There is the pain of rebellion: I began to replace the pencil with the razor blade. My fear of blood was greater than my fear of pain from a wound. It was then that I realized that I had to confront my fears, which liberated me from my fear of blood. That runs through all my work. In the performance *Rhythm 0*, I risked being killed. I tempted fate.

# Rhythm 0

Instructions

There are 72 objects on the table
that one can use on me as desired.

Performance

I am the object.

During this period I take full
responsibility.

Duration: 6 hours (8 pm – 2 am)
1974
Studio Morra, Naples

This performance is the last in the
cycle of rhythms.

I conclude my research on the body
when conscious and unconscious.

List of objects on the table:

| | |
|---|---|
| gun | mirror |
| bullet | drinking glass |
| blue paint | polaroid camera |
| comb | feather |
| bell | chains |
| whip | nails |
| lipstick | needle |
| pocket knife | safety pin |
| fork | hairpin |
| perfume | brush |
| spoon | bandage |
| cotton | red paint |
| flowers | white paint |
| matches | scissors |
| rose | pen |
| candle | book |
| water | hat |
| scarf | handkerchief |

sheet of white paper
kitchen knife
hammer
saw
piece of wood
ax
stick
bone of lamb
newspaper
bread
wine
honey
salt
sugar
soap
cake
metal pipe
scalpel

metal spear
bell
dish
flute
band aid
alcohol
medal
coat
shoes
chair
leather strings
yarn
wire
sulphur
grapes
olive oil
rosemary branch
apple

I risked being killed.

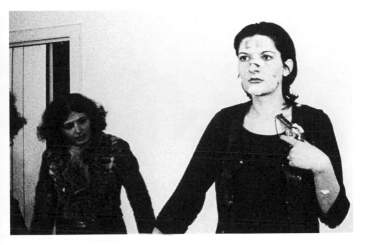

I've always felt responsible for everyone.

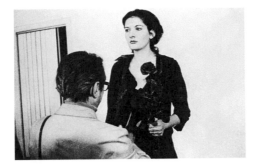

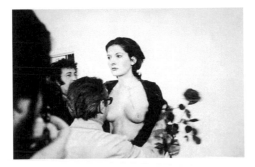

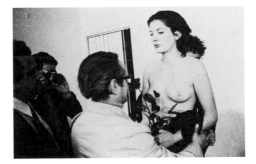

I go so far until it hurts so much
that I no longer feel anything.

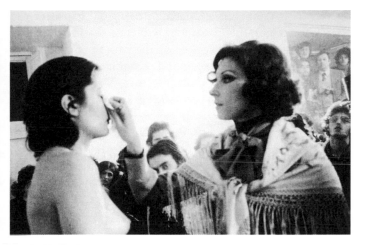

MA    And now, today, I'm seventy[1]—it's interesting, it must be something Slavic—and what is left is melancholy. The melancholy is always there. Every Slav who can feel knows this melancholy.

> It is striking that Marina never enquires after the source of this pain. The violence that ought to be explored as the source of the pain remains hidden. Marina presupposes it and recognizes it as a constant factor in her life. Only violence can cause pain, and violence is also the cause of fear. Does pain have meaning insofar as it can express fear as a feeling that has a name, is physically perceptible and hurts, making it possible to shut down all other emotions such as fear? What a brilliant transformation!

MA    If one inflicts pain on oneself to free oneself from fear, then pain is acceptable.

> The fact that Marina gave spectators in Naples the chance to kill her without having to assume the responsibility for their act was a way of challenging herself to face up to her fears of death. One cannot do that of one's own free will. If, as Marina says, performance is a means of coping with fear, then *Rhythm 0* is about mortal fear. Once before, in her planned performance *Untitled*, she had been willing to put her life on the line.

# Untitled

*Unperformed project*

Proposal

Gallery space

I stand in front of the public dressed in
my regular clothes. At the side of the stage
there is a clothes rack on which hang the
clothes that my mother wanted me to wear.
Slowly I take the clothes one by one and I
change into them. I stand facing the public
for a while.

From the right pocket of my skirt I take a
gun. From the left pocket of my skirt I take
a bullet. I put the bullet into the chamber
and turn it. I place the gun to my temple.
I pull the trigger.

This performance has two possible endings.

1970
Galerija Doma Omladine, Belgrade

List of my mother's clothes for me:

Heavy brown pin for the hair.

White cotton blouse with red dots.

Light pink bra, two sizes too big.

Heavy flannel slip. Dark pink. Three sizes too big.

Dark blue skirt. Mid-calf.

Heavy synthetic stockings. Skin colour.

Heavy orthopedic shoes. With laces.

KOSA
So svelom

BLUZA
Belo so
tufnicama crvenim

grudnjak

SUKNJA
plava

To Je ROZE
od Flanela
DVA
Boja ver

čarape
debele boje
kože

cipele
ortopedske
So tvrdim donom
no šnjtkanje

The Belgrade gallery did not allow this performance to happen, as it might have had a fatal outcome. Marina was 24 when she created *Untitled*, and 28 when she performed *Rhythm 0*. At the time she was living with her mother, who wanted her daughter to account to her for every area of her life so that Marina would not escape her control. *Untitled* is a wonderful concept for illustrating how Marina was trapped within boundaries and constraints defined by her mother. In the performance, Marina has to change out of the clothes she has chosen and put on the ones her mother wants her to wear. She might as well shoot herself. Her mother's demand that she exchange her identity, her ego, to conform with her mother's ideas and relinquish her identity—for the benefit of a mother who cares more about controlling her daughter than about her daughter's autonomy and development—is akin to the death of the self. Marina must give up her self to comply with her mother's wishes. Psychoanalysts call this the *self*-object: the daughter becomes her mother's object, and she can earn recognition only in this manipulated role. The wounded ego expects and desires fulfilment.

Marina has only ever experienced recognition and closeness in self-dissolution and the wounding of her ego. This she has instinctively grasped, and she exhibits this in remarkable fashion in *Untitled*. To have to give up your identity to fulfil someone else's

wish triggers fear, mortal fear. The ego is not permitted to exist. Fear and helplessness, rather than benevolence, become the glue of the relationship. So what does it mean if a gutsy, lively and creative young woman can only earn recognition through self-dissolution, only experience recognition as someone else's object and not as a subject? Marina transformed this into performance. *Untitled* shows how she has been betrayed. She has to change her clothes. She planned to perform her dilemma. She is no longer the powerless object but the subject of her art, while also controlling the violence against her, since it is she herself who stages it. This limits the fear and makes it easier to bear. It is an extremely creative act.

This is what Marina Abramović's performance is about: transforming the *object of violence* into the *subject of performance.*

Both performances, *Untitled* and *Rhythm 0* (to name but those two at this stage) speak of a tremendous mortal fear and a lethal threat to Marina's identity. We must take this seriously, for a performance like this cannot be created from nothing. A performance like this is created from experience.

Yet what is the violence from which these fears stem? What is the lethal violence to which Marina bears witness, and to which she is subjected? Marina

doesn't question this violence; she presupposes it. She doesn't mention it, presumably because she has never learned to interpret it and to recognize that she is entirely innocent, or else because silence is every victim's primary defence against violence. That is because silence means that one has no (more) words for what one has experienced, because it was unbearable and also because there was no one listening.

Marina knows no alternative to violence: all her performances make this clear. Violence is a continual and integral part of her life and upbringing. She learned to grow up with it and live with it. Her performances clearly show how the violence is being re-enacted and directed at her. In *The Artist is Present* at the Museum of Modern Art (MoMA) in New York in 2010, Marina sat on a chair for ninety days, eight hours per day during the week and ten hours per day at weekends. This was a repeated attempt to cope with the pain of violence, to stand and withstand it. It is also the re-enactment of an intractable situation. If she leaves her chair, the performance has failed. The unbearable pain of immobility, fear, losing consciousness, being reduced to keeping still and silent, and being robbed of any freedom of movement, are a re-enactment of the familiar violence. Marina can placate her mortal fear by tempting fate in such a radical fashion: it must show her whether she is entitled to live, or else release her from this bind and unblock her path to death.

*Untitled* has two possible endings: Marina either lives or dies. It is her quest for the right to live. The radical nature of her performance suggests that Marina doesn't know whether she is entitled to live or not. She places the decision in the hands of others—fate's in *Untitled*, and the public's in *Rhythm 0*. If a child has an experience of being wanted, it has a first binding relationship. This experience will nestle inside it, and the child will always be able to hark back to it and draw on it, thinking, "I mean something to someone." *Untitled* and *Rhythm 0* show that Marina doesn't have this inner reference point. In those performances, she gave strangers and fate the chance to decide over her life. Whereas in her early performances she accepted the risk of being killed, from this point on she tried to live with the dilemma.

This is what Marina Abramović's performance is about: staging an existential dilemma.

Forced to wear the clothes her mother wanted her to wear
and not to die
but to live with them

The monstrous dilemma she now expressed in her art involved enduring something until the point of unconsciousness, until the brink of death. Her battle with death had begun. It was to be a battle against this life's destruction and obliteration. I attribute the

fact that Marina is able to transform this battle into art to her creative brilliance and vitality.

She turns her dilemma into art. This became the sole place where Marina could survive by re-enacting the violence and her fear of it time after time in every performance. She has been able to use the ritualization of violence to create a place in which she can keep testing and proving her capacity to endure pain. She keeps showing herself that she will not go under, and will survive her fear.

MA        I was six, and my father was teaching me to swim. He lost patience. I think I was learning to swim, but I was so scared of water. He launched the boat, rowed me out to sea, picked me up as one would pick up a puppy, threw me into the water and began to row away. I panicked, slid underwater, screamed and screamed. I was swallowing so much water, but he didn't turn around—he just kept rowing away. Then he did stop, but he didn't row back. I could see his back and I was so angry. I could drown for all he cared; he didn't even look back. I began to swim towards the boat and he stretched out his hands, without looking at me. He simply heard me coming, pulled me out of the water and put me in the boat.

Marina's life is defined by her struggle not to go under and to swim against death. She will swim towards optimism, the hope of reaching the safety of a boat and firm ground beneath her feet. She will

keep striving and searching for a way to reach what is not on offer. She knows what she is looking for: love, recognition of her ability to live, her right to live, reliable and binding relationships. She is looking for the right thing in the wrong place. She is looking for it where it will be denied to her, as it was when she was a child. She re-enacts it in the place where she remains tied to the longing for recurring pain.

In the following sections I shall refer again and again to the violence that causes this pain and reveal it in its many facets. It is the violence of experience, which leaves no choice. Inextricably entangled in it, Marina manages nonetheless to lend it a voice. That is her force and her strength; that is the hallmark of her brilliance. As *The Artist is Present* so clearly demonstrates, she raises this dilemma to a higher level of meaning.

This is what Marina Abramović's performance is about: searching for a relationship through re-enactment.

The performances that followed *Untitled* and *Rhythm 0* were stagings of the *persistence of this dilemma*. Whereas Marina tempted fate back then in her search for an unequivocal answer to the question, "To die or not to die?" in future she wouldn't wait for this answer. There would be no performances that did

not have this dilemma at their core, nothing that did not feature the violence against her life, her vitality, her freedom of choice, or with the fear of this violence. Just as Marina had to replace her own clothes with those her mother had chosen in *Untitled*, she has made her art serve the re-enactment of the dilemma. She wears her own clothes, but she is not actually allowed to wear them. She wears the clothes her mother wants her to wear, but she wants to wear her own. Her ego is compelled by her mother's wishes, and if she doesn't fulfil them, by guilt and punishment.

Wearing her mother's clothes subjugates her ego, her self-determination and her autonomy. The pistol is the symbol of this unavoidable, crushing destiny. The fact that Marina provides fate with a possibility not to kill her in *Rhythm 0* is testimony to her hope. She wants fate to grant her the love she craves and allow her to be loved and desired; she wants fate to offer her life, not death. Yet that is not how it turns out, for Marina's wish is not to be fulfilled. In Naples the public didn't react to her suffering. Abandoned, she must face violence alone, and in Naples the police were ultimately called to the scene to break off the performance. Marina is the object of violence committed by someone else or by various other people. Throughout her life she has been denied the chance to be the subject of non-violence, or to be able to think and feel that she is innocent.

This is what Marina Abramović's performance is about: being the object of violence.

Bound by her own wishes and those of her mother, without the clarifying answer she longs for fate to provide, Marina's only escape is to stage the impossibility of escape.

# Guilt and punishment

If an obvious need, such as wearing one's own clothes, becomes a matter of life and death, a matter of guilt, then the opposite is equally true. If changing clothes and subjugating herself to her mother's wishes lead to the death of Marina's self-determined ego, then her non-subjection would conversely lead to the death of her mother's ego. This means that Marina's efforts to be independent and decide on her own life threaten to cause her guilt and harm her mother's ego. This leaves her no option, as she explains:

MA      I can't deprive others of me—it will kill them.

For a psychoanalyst this is a clear reference to a violent mother who is dependent on her daughter's vitality, needing it the same way a vampire needs blood. At the same time, this daughter is not allowed to escape into independence, not permitted

to elude her mother's control so as not to deprive
the mother of the elixir of her life.
— The dilemma is: Either the mother's ego dies
or Marina's does.
— The dilemma is: Marina will be guilty as soon
as she becomes conscious of her ego.
— The dilemma is: Marina will be guilty as soon
as she becomes conscious of her innocence.

Her guilt leaves her no escape. This is because she
must deny herself, because she is giving up *her own*
clothing so as not to feel guilty towards her mother.
The difference between this and later performances
is that Marina stops tempting fate. The potential
outcome of a performance will no longer be death.
She has given up hope of being granted the right to
be herself, along with the right to a loving relation-
ship and recognition. She will carry this absence in-
side her, and she will try to give it meaning.

I would like to emphasize the fact that Marina had
no other choice during her childhood and youth
but to get used to violence and her fear of it, and to
come to terms with them, not least because she had
no one to stand by her side and show her love and
goodwill. The love she has experienced is a love that
is bound with the pain of inevitable self-dissolu-
tion. She has to give without being allowed to *want*.
This love is therefore unworthy of the name. It is
toxic— *Toxic Love*[2].

Marina realizes that she cannot escape. She recognizes that the boat does not wait for her, that her screams go unheard, her clothes disregarded. She attempts to chart a path for herself and to stay alive within the confines of the bearable guilt that she continually seeks to process in her performances. She no longer searches for esteem in the outside world, but by looking inside herself. In the process she perhaps forgets that she will have to sacrifice the basic *right to recognition*—every child's fundamental need to be welcomed and acknowledged. She perhaps forgets that where others can draw on an embarrassment of riches, she constantly has to invent and keep finding a way to create riches out of nothing. This invariably requires a tremendous effort. Creating something from nothing comes at a price of unrelenting loneliness—Marina's loneliness as a child and a young woman, receiving no affectionate signs of attachment and reliability. Although her parents were present, I presume that they were not available emotionally or to provide her with a reliable attachment. As a result Marina learned to make herself available for her parents, because experience told her that she could gain at least some affection that way. She had to be there so that she might be used, and to ensure that she did not miss out on anything, including affection.

The inside
turned out
until its memory
fades

That constitutes serious abuse. She continues to look for affection; she continues to relieve others of their responsibility, maintaining and entertaining them, carrying them and caring for them, converting their violence against her into her own guilt or debt. Just as she has always done. "I am the object. During this period I take full responsibility."[3] From that point on Marina's understanding of a relationship is to take full responsibility for others' actions and sensitivities. For her this sense of guilt/debt will be the key to the relationship and its glue. It features in the re-enactment of her own past, in which guilt plays a central role—guilt towards the mother if Marina doesn't satisfy her wishes by changing her clothes. Ulay[4], her first long-term partner, and Paolo, her ex-husband, are reproductions of lovers who exploited Marina's willingness to recognize and fulfil the needs of others.

This is what Marina Abramović's performance is about: working away at her guilt/debt.

If Marina doesn't take responsibility, she exposes herself to the guilt of thoughtlessness. She is punished for this "thoughtlessness" with rejection and a

withdrawal of affection. Being excluded from a relationship is unbearable whatever happens, because, as Marina states, "I always end up alone." Exclusion from a vital relationship such as the one that parents must provide is murderous. Marina's performances demonstrate how she copes with and survives this unbearable situation.

# The Artist is Present

MoMA (Museum of Modern Art, New York)
14 March to 31 May 2010

A retrospective of all Marina Abramović's
work. Some of her works are re-performed
by trained artists for the duration of the
exhibition.

Simultaneous performance of *The Artist
is Present*: For 90 days Marina Abramović
will sit facing visitors, motionless and
without interruption, during the museum's
opening hours (eight hours per day on
weekdays and ten hours per day at week-
ends), staring into their eyes and focusing
her entire attention on them.

Pain is a door.

I give absolutely everything.

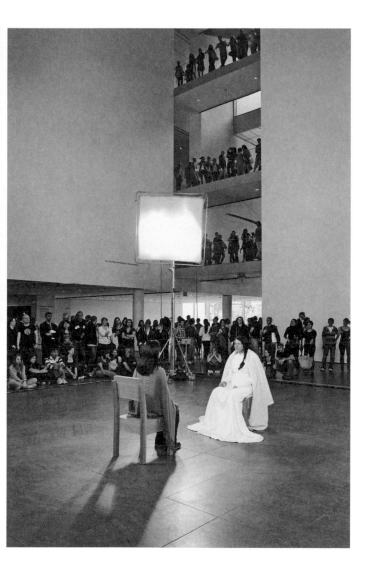

It isn't dying that scares me.
It's the unstoppable passing of time.

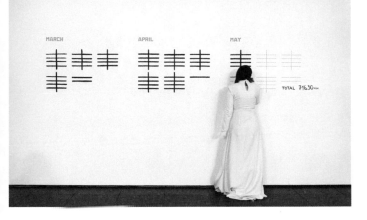

I always end up alone.

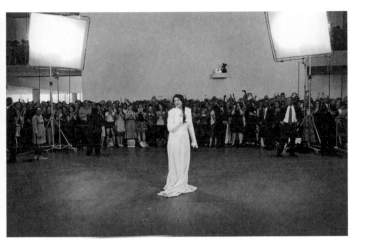

Sitting on a chair for over 700 hours and being unable to satisfy her physical needs (which of course cannot be held in check for very long) is a sign of this guilt, this punishment and penance. Marina called this performance *Mission Impossible*. To this day Marina has never mentioned that this guilt is not her own, that it was her parents who refused to take responsibility for their daughter and replaced responsibility with control, and that it was Marina who had to take responsibility for her mother, not the other way around. The question of guilt remains unexplored, and her parents are protected and exonerated. Marina will continue to work away at the guilt for as long as others refuse to take responsibility. The burden of this guilt leaves a sediment of melancholy. Marina has also said, "Melancholy is always there, for I believe it is in the Slavic genes." The fact that Marina assumes that melancholy is inherent in the Slavic genes is a sign that she leaves the violence that causes this burden and this melancholy unchallenged; she accepts it as a genetic factor.

MA     I didn't know if I would make it to the boat. I was panicking. He didn't even look around for me. He kept rowing and left me alone. I was completely reliant on myself. Oh, that's so interesting: I always end up alone. That is exactly the situation he put me in. In that water I am so alone, alone with my own fate. No one cares if I swim or sink. Yet it is that same energy that made me sit on the chair for three months during *Mission Impossible* (MoMA 2010,

*The Artist is Present*). It's the same energy, and I did it the same way I swam to the boat. I am swimming. I am alone. Everything is in my own hands. I am unloved and reject-ed—and I survive.

This is what Marina Abramović's performance is about: an exercise in survival.

MA      But I didn't instigate the thing with the boat; I was put in that situation. I instigated *The Artist is Present*. One I was responsible for, the other I wasn't, but how and why are they linked? It's difficult to understand.

If neither the father nor the mother can be incorpo-rated into a person's inner life as a reliable and be-nevolent entity, on which a person can draw at any time through memories, then that person will have to keep practising swimming:
— As a test of strength: to be ready to swim at any moment;
— As a test of courage: to be able to face up to vio-lence at any moment.

These are connected to the undying hope that she might experience affection and attachment. Marina knows no other way. It is a tug-of-war with vio-lence. Will it win or not? Will it kill me, will I be destroyed, or will I once more survive?

This is what Marina Abramović's performance
is about: withstanding violence.

However, each of her performances also contains
the hope (even if it is unconscious) that this one
might be the last. Marina has no vision of what it
might be like if it were to be the last, because she
doesn't know what that means; she doesn't know
any other way.

MA        If someone really loves me, I don't believe it.

Pain is essential and valuable for Marina, for it
stands for love. In her later performances she attrib-
utes an additional meaning to pain: it is the gateway
to a transcendental, spiritual space, and universal
love. However, this transcendental love sacrifices
earthly love.

It isn't love when she is thrown into the sea.
It isn't love if pain becomes her precondition.
It isn't love if she reaches the boat in fear and panic.
It isn't love if that love has to be forged in
agony and fear.

However, for Marina all of those things are love.
Throughout her entire life Marina has never en-
joyed the support promised by the boat: the shelter
of a solid, loving relationship. To be supported,
Marina has to support others. So Marina wards off

her fear by ritualizing loneliness and a lack of shelter in her performances, and at the same time she is able to create support for herself through repetition. Marina knows that she can swim. It is the only thing she knows for sure. Swimming becomes her support, her buoyancy aid. She invented *Mission Impossible* to make sure that she has another buoyancy aid.

This is what Marina Abramović's performance is about: support comes from re-enacting helplessness.

*The Artist is Present/Mission Impossible* is an enactment of a painful relationship. It is the re-enactment of a real liaison, turned against herself. Someone who is forced to endure a relationship as agony and pain, as violence, turns this same violence against herself, because she knows no alternative.

This is what Marina Abramović's performance is about: the enactment of a violent relationship.

JF        You said that pain leaves *you*. Does pain leave you, or do you leave pain?

MA        I think I leave pain. Because I don't take painful things on stage with me any more. My relationship with pain has changed. I don't have to do it any more. And now, when I look deep inside myself, I have somehow made it

through all the pain and it has become my friend. I know it well and in many ways I trust it. I don't need to prove anything to anyone, because both my father and my mother are dead. And I no longer feel any love for my husband, who broke my heart. I was in such pain that love became unfeeling. I no longer feel anything.

JF     Can one deaden feelings with pain? Feelings such as love, as you say, even anger and hatred? Or is it just that those feelings now have no target and turn against you?

MA     Pain is a door. A secret door into a different state. Without these doors you can't reach it. Afterwards, you no longer fear pain. The pain disappears. You go through hell to get to this point, but when you get to this door and open it, you never forget that you're here. Beyond that door the physical body no longer matters. There is a new transcendental energy.

JF     You must have suffered from unbearable pain in the performance *The Artist is Present/Mission Impossible*.

MA     Unbelievable pain. For eight hours during the week and ten hours at weekends. I was in such pain I couldn't even take off my dress. I couldn't lift my hands; I couldn't even let people touch me for a massage. It was all pain. The first month was terrible, the second intolerable. Then came the third. I took away the table and, ah, something clicked. My whole body became a receptor and emitter of energy.

Pain gives feeling to fear        61

JF        Why does pain open the door and not desire, love or joy? Would it be risky for you to renounce pain?

MA        It's very simple: it's to do with fear. You're scared of pain, you're scared of life's transience. Confronting fear means exposing yourself to pain. If you cause yourself pain to free yourself from fear, then the pain is okay. This conversation is very interesting.

So the question of pain is a question of fear. Pain seems to relieve the fear; it appears to give a name to fear and a meaning to pain. Again and again Marina makes room for pain. She makes lots of room for it in her performances and in her interactions with the public. In *The Artist is Present/Mission Impossible*, pain fuses the two subjects of the performance together. Marina and her seated counterpart touch and are united by pain, and what hurts is fear. Pain is an attempt to transform fear into something palpable, something physical, into something that has a beginning and an end, something that has a language, a wordless language that says, "There is something here." Because fear is diffuse. Because fear is an expression of impotence, and impotence excludes all feeling. Fear banishes all feelings. It causes them to vanish, and pain reinstates them. Pain gives fear a face, a face one can look at. It is a hideous face, and yet it is more bearable than nothing, than the facelessness of fear.

There is no sign or sensation of pain in Marina's performances. She puts up with it bravely and silently. All alone. Were Marina to put an end to the pain, her performances would be over. They would have "failed", at least from Marina's perspective. She would have failed. She would not have lived up to either the public's expectations or her own. The public would be disappointed, the curators too, and maybe even her friends. Either she endures, or it is possible and likely that people will turn away from her in disappointment, and her success would collapse. This is the same traumatic dilemma again.

This is what Marina Abramović's performance is about: nobody notices her pain.

Nobody has any inkling of her agony in *The Artist is Present/Mission Impossible*. She doesn't show it. She copes with it on her own. A trouble shared is a trouble halved; on the other hand, pain that is not shared, silent pain, lonely pain, is unbearable. The end of pain is the end of fear, and also the end of the performance. It is replaced by profound relaxation, a deep sense of serenity and freedom whose cathartic effect stems from the preceding violence.

But what is this fear? In *The Artist is Present/Mission Impossible*, Marina is not allowed to move. She is not allowed to stand up and go to get something to eat or drink or go to the toilet, stretch her legs, have a

chat or take a break. In *Untitled* she is not allowed to keep her own clothes, maybe not even her life. In *Rhythm 0* she is not allowed to resist and protect herself from the public's violence. She must give up her own needs and wishes; she must withdraw into motionlessness. As she puts it, "I shut down until I die, until I disappear." That is the extent of the violence against her life. That is Marina's pain. That is her mortal fear. Mortal fear is the inevitable consequence when the self is forced to subjugate itself to immobility and selflessness. Fear is always the response to violence.

Marina avoids fighting fear and even coping with it, because otherwise she risks exposing the underlying violence. If this violence is exposed, the numbing fear and impotence will flare up into emotion, perhaps anger and hatred. Why doesn't Marina challenge this violence? Might it be to shield other people from her anger? Pain and fear are a constant feature of Marina's life. She calls pain her friend. She wants to stop performing it, but it is still her friend. She wishes to have it available when she needs it—when she needs it to help her overcome her fear.

This is what Marina Abramović's performance is about: pain is life.

# Alone

MA    A recurring feature of my life is the experience of being alone, of being abandoned. It's the only truth I know. It was also the only way I ever did things in my childhood—alone. I knew no other way. But why do I repeat this? To feel alive? Or to see that I can be alone? To prove it to myself?

Marina's father abandoned her when he split up with her mother. He disinherited her, as her mother later did too. Her brother won't talk to her. Her first and second loves of her life left her. Given this series of repetitions, it stands to reason that Marina thinks that she is to blame. The fact that she asks, "Why do I repeat this?" shows that she assumes that *she* is responsible.

Her performances provide a key to the answer. For over 700 hours Marina sat motionless on a chair in *The Artist is Present/Mission Impossible*, staring into

the eyes of the people facing her. In the film of the same name she says, "When those people sit opposite me, it is no longer about me. I become the mirror of their own self." These were her instructions to the young artists who repeated her performances at MoMA: "The aim is to slow down your body and your mind so much that you no longer feel gravity. The hardest thing is to do almost nothing. It takes *everything* out of you."

To empty oneself
to the point of abolishing one's own weight
and importance—
to become a mirror.

The "emptier" the mirror, the greater the area of projection. The person opposite can make his or her reflection wherever he or she wishes, and as big as he or she likes. And that makes her lonely.

This is what Marina Abramović's performance is about: her emptiness becomes someone else's fullness.

The people who attended the *Rhythm 0* performance were terrifyingly creative in their abuse of her, even going so far as to harbour lethal intentions. To make herself available for the public's needs Marina has to erase her own. That is her formula for relationships: love and relationships mean

taking responsibility for the satisfaction of other people's needs and making herself available to them. To do so she must inevitably discard her own needs and get rid of her self. This makes her lonely. Despite being surrounded by thousands of people, a mirror is alone because it is acknowledged only as a mirror.

MA    I am always filling my mother's emptiness with my work. I fill her emptiness with my life.

JF    Do you mean you *fill* or you *feel* your mother's emptiness?

MA    No, I fill it, like filling a vase with water. I don't want any more relationships in which you take out your own core, your own centre, and put it into the centre of someone else. My whole behaviour has changed. You came and I said, "Make lunch for yourself." I can't believe it. I've always felt responsible for everyone. I cooked and cleaned for everyone. All that has changed now. There are four people here and I'm totally relaxed. I wake up in the morning, I go swimming, I do my meditation, prepare my meals. Everybody does everything. And all of it happens without me controlling or leading, and I just can't believe it. I never dreamed that this was possible. And it's the first time I've ever done it.

This is the first time Marina doesn't take responsibility for satisfying other people's needs and wishes.

Her doctors have urgently warned her to do everything she can to look after her health or there could be serious consequences. These doctors' warnings show just how strenuous and unhealthy it is to dissolve oneself for someone else's benefit. A statement by Ulay in the film *The Artist is Present*[5] gives a striking illustration of how people use Marina and demand her self-dissolution to fill and enrich themselves: "This may sound strange, but I don't have the time and energy to make all this [he means success] possible. But I don't have to: I can just marry her."

The re-enactment of her exploitative relationships, the repetition of the need to fill and feed other people, hints that the same processes were at work during her childhood and youth. By this we mean the pain re-enacted in her performances, for it hurts to dissolve oneself for someone else's benefit. What is harder—and makes it so inescapable—is the fact that if there is no self-dissolution, there will be no affection. This acting out of her relationship in her performances reveals the pattern of violence: the diminishment of her self into frugal immobility is accompanied by the debasement and humiliation of being consigned to this state. Relationships are associated with pain and fear in Marina's life. The pain of defencelessness and powerlessness. The pain of exploitation. Marina produced relationships, closeness and contact through the pain of self-dissolution.

This closeness is violent, as her performance *Rhythm 0* shows in such striking fashion. It is not only that she is stripped, not only that someone places a loaded pistol in her hand and points it at her neck, but also that most people take her up on her offer to make herself available. Visitors are willing to use her for their own projections and needs, ignoring the subject before their eyes, especially as Marina relieves them of their responsibility and takes it upon herself. *Rhythm 0* demonstrates the loneliness of the performer in equally eye-catching fashion. For Marina, a relationship means that nobody notices her painful loneliness, and nobody sees her. "She gives everything," says Klaus Biesenbach, MoMA's director, about Marina's performance in an interview with filmmaker Matthew Akers. He is right. She does give everything. What she is left with is not recognition for having given everything, but rather recognition for having created a void in which a person can see him- or herself reflected in whatever he or she wants.

This is what Marina Abramović's performance is about: she gives *everything*.

This is how it has always been ever since she was a child. She owes this to other people; she owes *herself* to other people.

Other people feed on her guilt.
Other people fill themselves with her guilt.

Ulay clearly expressed this in his remarks about marriage. When Marina no longer fills the other person, she is abandoned; when she expresses her own wishes, she receives no answer. Both Ulay[6] and Paolo[7] left her when Marina's own wishes begged for someone to listen to them. That isn't part of the plan in this type of relationship. The other person abandons his object—the object of its wish satisfaction—and immediately looks for another one. Without any argument, an argument between two equal subjects with different wishes and needs. Without acknowledging the differences between two independent subjects. If Marina's wishes for satisfaction do come to the fore, they fall on deaf ears; they vanish into the void, leaving as their only echo a debt to the other person. Both men reproduce the same type of exploitative relationship that Marina experienced with her parents:

Guilt is the glue of the relationship.
Owing *herself* to the other person,
owing them *everything*.

*Rhythm 0* and *Untitled,* to name but those two performances, reflect this violence. Marina is the object of events. In these performances, she demonstrates how she makes herself available for the public's

needs and takes responsibility for their actions without any thought for herself or for protecting herself. She enacts a relationship: a violent relationship like the ones she has experienced.

This is what Marina Abramović's performance is about: being trapped as someone else's object with no hope of escape.

None of her performances is about defending herself from violence. None of her later performances ever mentions this all-consuming, yet purely subcutaneous violence. Therefore, that fear—the all-consuming fear that inevitably signals violence —remains hidden. It is impossible for Marina to think outside a framework of guilt, to think of herself as innocent. She exhibits her selflessness and powerlessness to the point of impotence and unconsciousness. It is an attempt to push herself to the brink of death. She is looking to see the extent to which she can suppress life.

This has four extremely important advantages for Marina:
– She discovers and experiences with each performance how far she can push the suppression of herself; she knows that she can still do it, and she knows that she can satisfy other people and reassure them that they are important. That is how she forged relationships with men like Ulay and Paolo, who

required Marina's abasement for their own self-aggrandisement, as her mother had previously done.

– She has served her sentence! Again. The sentence for her many independent movements that have escaped her counterpart's control. This counterpart would like to retain control of her in all circumstances so as to avoid forfeiting nourishment and filling.

– Marina's sighs after the performance give some indication of her enormous relief after the agonies—hellish agonies, as Marina calls them; she feels a sense of liberation from guilt and fear. A momentary freedom.

– She has anticipated and accepted the other person's aggression and directed it at herself in the accustomed manner so that she is now in control of that aggression. No one ever again—no men and no mother. Psychoanalytically speaking, that is the only sensible thing she can do if she is to survive. She can take control of another person's destructive intentions. By anticipating violence, she takes control and determines when it begins and when it ends, and its intensity. It is in *her* hands to transform the impotence caused by violence into power.

Again and again, Marina gets up and performs, just as she kept getting back up when she was a child. She gets up for each new performance in order to prove to herself that she is still capable of enduring it. Marina gains the right to live by re-enacting violence. This comes at the cost of remaining with the

perimeter of annihilation and the failure to recognize annihilation. Every one of her performances involves an attempt to get as close as possible to annihilation and push herself to the very limits of what is tolerable so that afterwards she may be free. The public are her witnesses.

The striking thing about Ulay's statement in the film *The Artist is Present* is his tacit assumption that Marina would *want* to marry him. The fact that he doesn't involve her in his own wishes and needs —doesn't involve her as an autonomous and self-determined subject, but uses her for his own purposes—is the direct legacy of her experiences with her mother. If she wishes to be with a man like Ulay or Paolo, she has no choice but to retreat into selflessness. That is the price she pays for the love (marriage) he promised her: being the object of his wishes.

MA     In the late eighties, I had a big show at the Centre Pompidou in Paris. It was a massive thing, huge. I invited my mother to the opening. She rang me to ask whether I was going to be naked. I said no, so she came. I scrubbed my home clean, every last thing, even though she was staying in a hotel. When she came to see me at my studio she ran her fingers over the furniture and said, "Relatively clean." The opening was the next day, at 6 pm I think. I didn't want to get there first; I wanted to turn up around 6.30. She went directly from the hotel to Pompidou at six. I was amazed when I arrived. I saw my mother standing in the middle of

the exhibition, surrounded by people, explaining my work to them. *It was as if she were me.*

Marina's mother appropriates her; she dispossesses her of herself. She fills herself with her daughter: It was as if she were me. If a child is consigned to this role as an infant, it has no choice but to give everything, as Klaus Biesenbach says in the film; to give *everything* to obtain a minimal form of recognition, even if it's just a dismissive "Relatively clean" or Ulay saying, "I can just marry her" or Paolo, who benefited from the success of *The Artist is Present/Mission Impossible* for a year, leaving Marina as if he were a leech that had sucked its fill. Amid all these events, Marina had the same experience she had repeated ever since she'd been an infant: love and recognition are only on offer if she gives everything, makes everything available to others and fills them until she loses consciousness.

Her success only confirms this assumption. She is celebrated for enduring violence. It is a brilliant feat to turn this inescapable dilemma into art and to stage herself as an object in order to become a subject. Her own needs are suppressed for the benefit of a counterpart who desires to see her in *precisely* this role. She exposes herself; she gives *everything (up)*. From self-dissolution she creates greatness, and in her self-dissolution she is recognised as great: that is her genius.

Since the world's
been round,
there's been no edge
to fall off

# The umbrella

MA     Then the umbrella. My mother had an umbrella with a cover. In addition, she had a see-through plastic bag to wrap it in, and an even thicker plastic bag to wrap it in again. Three covers for one umbrella. It was completely nuts. It made me paranoid. I threw away every plastic bag because I couldn't deal with them. One day, a few years before she died, I was so tired of this plastic bag stuff; it was raining and we were going out. I went into the kitchen, picked up the really thin plastic bag and the thicker one and took them to her. It was the first time I'd given them to her. She smiled, and I smiled because she was smiling. That is the only happy moment with my mother I can remember—the moment I brought her those plastic covers and she smiled at me. And of course, she wrapped her umbrella in both of them. It is also the only moment when I sort of gave up fighting. "Here are the plastic bags. Take them!" I just gave them to her, without any comment, and then she smiled. I accepted the craziness of those plastic bags. I simply gave them to her. I had usually always complained, "Are you

mad? Why do you need those stupid plastic bags? The umbrella already has a cover!" There was always an argument. This time I just walked off, brought her two bags and she wrapped the umbrella in them without a word, but with a smile on her face. I felt warmth in her smile; it was a form of connection. I'd like to understand what happened.

Her mother's smile was undoubtedly a happy smile. Marina made her mother happy. But how? She had abandoned her own view and adopted her mother's: an umbrella needs three covers. This anecdote mirrors the wider drama. Marina gives up her position, and her mother is happy because she feels confirmed in hers. That reassures her mother, and Marina knows this. If Marina were to refuse to complete this task, then her mother would be destabilized. Marina knows this too: "I can't deprive others of me—it will kill them." Marina will therefore make any other person happy so as not to feel guilty about them. She will give up her position until she is impotent, as her performances show. Her independence is inescapably bound up with a life-and-death struggle. She receives a smile, a smile of attachment and recognition, about which Marina says, "That is the only happy moment with my mother I can remember." A smile of acknowledgement that Marina has given up trying to bring her self into the relationship. She doesn't bring her self into it. An umbrella needs three covers.

Thus, Marina's abnegation becomes a binding element in her relationships. The other person's smile confirms this abnegation and encourages it. There is no end to this hopeless enterprise, as others use and misuse Marina to reassure and fill themselves. Marina wanted to feel this closeness and this smile in future attachments, as she sought a moment of happiness. Yet that happiness is not real, because the pain of renunciation cannot be a precondition for happiness, not for closeness or a relationship, nor for enjoyment or success. Might it be the same with the happiness that follows a successful performance? A moment of redemption, a moment free from guilt and fear, a moment of freedom and safety? Because the tribute for it has been paid in the agony she has endured?

This is what Marina Abramović's performance is about: so much fear for one smile!

MA    Everything changed after *The Artist is Present/ Mission Impossible*. I went through an incredible metamorphosis. My entire self. But I wasn't strong enough, and then Paolo came back. He came back for a whole year. It was the worst thing possible! And then he left for good. It is a pattern that continually repeats itself, affecting my entire emotional life. My mother never left me, only my father. My life is all about being abandoned, so I always have the feeling that there's something wrong with me. Why am I not good enough?

Strictly speaking it is not a matter of being aban-
doned. Not at all. One is abandoned when there is a
relationship based on a *recognition of difference*—the
recognition that the other person is different from
me, free from guilt and the fear it produces. "I had
to fill her, like filling a vase with water," Marina
says. This was the only way that she could gain rec-
ognition from her mother, Ulay and Paolo. When
the glass is full, or if the water is too warm or too
cold, the parasite looks for a new host. So Marina is
not abandoned because she is inadequate, as she mis-
takenly believes each time. She is replaced—the
classic form of exploitation. If it is the mother who
does the exploiting, and the father doesn't inter-
vene, the child is defenceless and exposed to abuse.

This is what Marina Abramović's performance
is about: it allows her to control the abuse better.

The child assumes that what it experiences is love,
and that love hurts, love is scary and love demands
that it give *everything*.

MA        I was in such pain that love became unfeeling.

Her father didn't take his daughter with him when
he left his wife, even though Marina had to be hos-
pitalized for panic attacks that seemed to go on and
on. What Marina unconsciously understood was:
now I am alone forever. Alone with a mother who

isn't a mother, a mother who fights her daughter; alone with a debt towards this mother who *demands* everything of her daughter. This will be the formula for Marina's later loves: abused love.

Marina experiences emotionally what she expresses in the film *The Artist is Present*: "I am nothing without the other; I'm only emptiness." The feelings of impotence that spread through her after the men have left are not grief or anger at the break-up, but impotence and a fear of not being able to live without the other. When the other's vase is filled and he leaves, in order to fill *his* emptiness, he steals the water she needs to fill and feed herself. He has no thought of evening things out. The relationship is therefore reversed: the others cannot live without Marina. Paolo came back to MoMA, and Ulay was still claiming in 2012 that Marina would marry him and fill him with her success and money. If she were to savour or enjoy her own fullness, she knows from experience that disaster might ensue.

MA    I always thought that if I did something nice or if I felt good, I would be punished. I thought that happiness leads to disaster.

Happiness doesn't lead to disaster. It is envy that threatens happiness and seeks to destroy it. "Mirror, mirror, on the wall…" and the hunter is dispatched to kill Snow White. This is the role of fairy-tale

stepmothers. Marina's performances allow her to pre-empt the disaster that experience has taught her to expect. Pain and a fear of envy's devastating blow are indisputably the most important elements of her work. They are the tribute she has to pay to happiness, for with them she curtails her happiness and enjoyment, and thus banishes envy. Marina's happiness is all about surviving her performances unscathed. For her, the 850,000 visitors who came to MoMA to see her are success and enjoyment. The agony of her performances pre-empts the devastating envy: she must not let all this happiness and success go to her head.

This is what Marina Abramović's performance is about: happiness is held in check by agony, thus banishing envy.

Marina relieves happiness of its weight and translates it into the hellish torture of performance. If, as Marina says, happiness leads to disaster, then happiness takes its toll. Marina pays the price in pain, allowing her to ward off the final, devastating, envious blow. This punishment is not dealt by fate—why should it be?—but by envy. Marina's past provides evidence that she will be abandoned if she is successful. She has sufficient experience that happiness leads to disaster, and that her happiness and her enjoyment will be contaminated with envy.

MA    There was always an imbalance between me and Paolo. He was going nowhere in his career, and mine was taking off. Every time someone in the street asked, "Can I take a photo?" or said, "I love you", it felt like a punch in the face to him. So every time he punished me for my success. He withdrew emotionally and turned away from me. Joy shared would be joy doubled.

> The pain caused by envy is never mentioned in her performances. Nobody mentions pain, nobody mentions fear, and nobody ever mentions envy.

> This is what Marina Abramović's performance is about: the unconscious hope that there might be a boat in which she would be welcome.

> Not a boat that she reaches with the last of her strength, or maybe doesn't reach. *Untitled* and *Rhythm 0* show clearly that death is a real element of her work. She hopes that someone will say to her, "I don't want you to feel pain." She unconsciously craves confirmation that she has a right to live, to be herself, and that there is somebody for whom I am somebody.

> Are we too enriching ourselves at the artist's expense? Are we also filling our vases with her water? There is a real question as to why so many people don't see, or don't wish to see, this pain and don't ask about it. Why do so many people—850,000 at

MoMA alone, 1,545 of whom sat down opposite Marina—get what they want from her and do whatever they want with her in their thoughts? Everyone has to question their personal responsibility when they decide to become part of the performance. For Marina the performance re-enacts the consumption of her, through which she received recognition and praise both as a child and in her performance: to receive what she describes as love. The only love she knows is making herself available to others. If Ulay still wanted to marry her in 2012, then what he meant was that he would gladly benefit from her success. Paolo came back to Marina for a year after *The Artist is Present* to consume her and her success before leaving her again. This is therefore not about being abandoned, as Marina always stresses, but about being cast aside. She is discarded because she is no longer useful as an object to the other person. Her successful transformation of this experience into art and performance, garnering Marina worldwide recognition, is a product of her extraordinary determination, an inexhaustible wellspring of ideas, her will to live and her desire to achieve recognition. She wants to be recognized as the subject of a performance, in which she displays herself as an object. At the same time, Marina's performance and international success reflect a hierarchical social structure, driven by violence.

# Mission Impossible

MA     It takes superhuman power to get through my performances. They wouldn't be possible otherwise. I didn't know if I would make it to the boat. Then I panicked. I was so alone in that water, alone with my fate. Would I swim or sink? No one cared. There is that same energy in *Mission Impossible*.

This is what Marina Abramović's performance is about: overcoming fear.

This *superhuman* strength is related to the *inhuman* situation. It took enormous strength to reach the boat and to survive *Mission Impossible*, because it is accompanied by fear and panic. Despite the thousands of people who walk past her, Marina has to face these feelings alone. Both situations demanded that she give *everything*, and Marina did *everything* to survive. She had no choice. It was terrible growing up in that equation, where inhuman situations demanded

superhuman power to survive. When she has nothing more to give, she is abandoned. Her great fear of physical dependence provides further illustration of this.

MA      I've always had low blood pressure. This year (2015) I was only in New York for seventeen days; the rest of the time I was on tour, in hotels, working with hundreds of thousands of people. I started to get very high blood pressure in Brazil and by the time I arrived in Australia I was very overworked. One night I was feeling so bad that the doctor came and I had 226/116, which is really high. I had to take some pills. It was terrible. I'm telling you this because they said I had to change everything. So I stopped and switched to alternative medicine to be able to continue my diet and stop the pills, which I'm doing now. I've started acupuncture, etc. and now it's slowly going down. I'm so scared of high blood pressure, having a heart attack and becoming dependent on others. My fear of becoming *dependent* is greater than any other fear I've ever known. I've always been independent up until now. I left former Yugoslavia with only the negatives of my work. No clothes, nothing. Everything you see I have achieved on my own, without men. But right now, because I'm overworked and stressed out, the thought of being dependent is driving me mad.

It is striking that, for all her physical symptoms, Marina has only *one very specific fear*. She wants to be healthy so as not to be *dependent*. Could it be that her fear of dependence is so central and she's even

afraid that fear will drive her mad because she knows there's no one there for her? If one is dependent, it is vital to have a helping hand. Is it because she knows from experience that she is alone? Does she think, "I will be robbed of my strength and ability to keep swimming and make the impossible possible? And then? If I can no longer do all these things on my own, what happens then? Do I sink? For good?" She does everything she can to get back to health and defuse these fears. That's what we understand when she says, "The thought of being dependent is driving me mad." Because dependence means no longer *being able to swim*, and therefore sinking.

Marina doesn't have any confidence. This inner reference point is unfamiliar to her. She never had anyone who comforted her and gave her confidence. Her father pulled her into the boat, and life went on. Her mother didn't notice her misery and didn't want to notice it, because she had failed as a mother; and life went on. They used their daughter as a means of filling and feeding themselves. Children feel fear and panic when their parents don't care for them, because this cruelly deprives them of their vital need for safety and security. That is precisely Marina's fear, for being dependent relies on someone looking out for her. Marina doesn't have this kind of reference point, though. I see Ulay as a continuation of this. Marina knows that he would marry her for

her success, and so she must be able to work. The same thing with Paolo. And that hurts.

This is what Marina Abramović's performance is about: the pain of loneliness.

In the song *Cut the World*, which she wrote specially for Marina, the singer Anohni[8] warns:

For so long I've obeyed
That feminine decree

I've always contained
Your desire to hurt me

But when will I turn
And cut the world?

When will I turn and cut the world?

My eyes are coral
Absorbing your dreams

My skin is a surface
To push to extremes

My heart is a record
Of dangerous scenes

But when will I turn
And cut the world?

When will I turn and cut the world?

You cannot invent confidence for yourself; it must
be embedded inside you as experience. If that expe-
rience is lacking, there can be no confidence, and
that really can drive you mad.

# Power over violence

MA      I have this recurring dream about killing my mother. She sees me kissing a boy, then she pulls me away from him. She pulls my hair until I fall over. She is laughing hysterically the whole time. I look at her and realize that she is mad. She laughs and looks at me and I grasp that she's trying to tell me that this madness will be passed on to me and I will go mad too. She often pulled me to the floor by my hair.

*How* Marina killed her mother in this dream goes unspoken. What does become clear, however, is that this is a mother who violently pulls her daughter away from men so that she does not go mad all alone. The story about the umbrella exemplifies this interpretation: Marina's mother gives her a kind smile as soon as Marina goes along with her mother's madness. Without her ability to make art, Marina would presumably have been dragged into her mother's madness by her hair. Through her work

Marina was able, if not to represent this violence, then at least to integrate it into her performances.

This is what Marina Abramović's performance is about: gaining power over violence.

If a child develops normally, it detaches itself from its mother and turns towards a lover of its own choice. Marina's dream reveals her actual situation: a mother who is resentful to the point of violence attempts to block Marina's path to her own wishes and needs. She pulls Marina away from the man. She wants her to herself; she wants to fill herself with her so that she won't be alone. Marina invents a performance in a successful attempt to steer clear of madness and guilt. It saves her life.

For Marina love and relationships usually mean being dragged into the vicinity of this madness and abuse. To her recurring question, "Why do I keep repeating all this?" I would like to answer: Because Marina, in her quest for closeness and love, always ends up stranded in the same place—in self-destruction. In the place where her mother tries to drag her into madness. This was the only place there was: the place of closeness.

Closeness means the destruction of her self.
Closeness means entering her mother's madness.
Closeness means falling into the clutches of envy.

Closeness means giving *everything* to fill the
other's emptiness.
Closeness means erasing difference.
Closeness means the potential death of the ego.

This is the place in which Marina is searching. She is
re-enacting the right things, and she is searching for
the right things: security and recognition of her
ego. "I simply want to be me—the real me, not the
one they want me to be." That this place is the
wrong one, because it is the place of the recurring,
annihilating answer—the answer of a mad and vio-
lent mother—isn't yet clear to Marina. She assumes
that she is solely to blame for this envy. She assumes
that it is her duty to fill others' emptiness. Marina
will not give up her search in this sinister place until
she is capable of recognizing her mother's violent
nature. It is a major inner undertaking to accept
that one's own mother is mad and violent. Often
the most natural path is to blame oneself in order to
avoid this terrible realization, especially if one's
whole entourage turns a blind eye to the violence
and offers a child no escape from its mother's reign
of terror because mothers must always be idealized
and inviolate. This inevitably drives the child into
loneliness—the same loneliness that Marina still
fears to this day and calls 'Slavic melancholy'.

Marina's performances are all about turning violence
against herself. This violence is either apparent, as in

her early performances, or else it remains hidden. In *The Artist is Present/Mission Impossible*, only the museum staff and the curator were concerned for Marina. Her pain was hidden, and she had to bear it alone, as always. Therefore, the answer to Marina's recurring question as to why she keeps repeating all this is extraordinarily simple: she is looking for closeness and wants closeness, as we all do; that is completely normal. What is not normal, though, is that she has only ever experienced this closeness as violence against her ego. This same violence is repeated in all her performances. By turning it against herself, she seizes power over the violence, making it more bearable. The violence is still silenced, though, sealing Marina's solitude. This silence is to be understood as her buffer against repetition. The violence she has experienced will continue to go unrecognized as violence, and will henceforth plunge her into lasting hopelessness.

Marina has no experience of benevolent closeness. This is the closeness she is constantly seeking, involving recognition of herself as a separate individual. In this quest she keeps coming up against emptiness and disregard, and disregard is violence. It doesn't matter whether it is closeness to herself or closeness to another person. Our closeness to ourselves is shaped by the closeness someone bestows upon us a child, or doesn't.

This is what Marina Abramović's performance
is about: fear and impotence become the glue of a
relationship, even one's relationship with oneself.

Impotence knows
no bounds

# Disregard

It is unbearable not to be seen and not to be acknowledged as a separate individual with one's own needs and wishes, and it is devastating for any child. Marina's mother refused to recognize Marina as an autonomous subject. She ignored her. She only acknowledged her daughter insofar as Marina was able to serve her mother's purposes as an object. That hurts. Marina translates the pain of this disregard into physical pain, giving it shape, a beginning and an end, and palpable content. There is something there! There is pain. There is not the nothingness that causes unbelievable pain and is also invisible. Disregard is a void. We should not underestimate this kind of violence simply because it is invisible. *Mission Impossible* is a transformation of this invisible violence into invisible pain.

This is what Marina Abramović's performance
is about: the *nothingness of disregard* is given palpable
content.

JF        As a child, you were not appreciated for what you
were. Now the whole world sees you. What does that mean
to you? Do you feel it?

MA        You know, I wish my mother were still alive. I'd have
loved to have gone with my mother to see Robert Wilson's
play *The Life and Death of Marina Abramović*,[9] to have seen
her watching the play. My mother was proud of me, but not
in front of me. I know that because when I read her diary af-
ter her death, I couldn't believe how emotional she was. If I'd
read the diaries while she was still alive, our relationship
would have been different. She was the coldest person imagi-
nable. She kept every newspaper cutting about me. Every
single one. She has a better archive than I do. But in every one
of the books and catalogues she had of mine, the pages show-
ing me naked had been ripped out. The book that used to be
*that* thick was now only *this* thick. All for her neighbours.
She lied to everyone too. She told people that Ulay was
Dutch, not German, because the Germans are fascists, and
she told them we were married. Everything had to be perfect
for the outside world. If we were arguing, shouting or crying
and the phone rang, she would pick it up as if nothing had
happened. She said, "Hello. Yes, we're sitting here, chatting."
She was capable of just switching like that, and showing the
outside world how wonderful everything was.

Her mother appreciates Marina's art when she can use it for her own ends. She doctors Marina's books and catalogues accordingly, ignoring, cutting out and throwing away anything that doesn't suit her. Marina's identity is disassembled and reassembled into an alternative version, one that her mother can use for her purposes—to show off to her neighbours and make them envious of her, the mother of a famous daughter.

Marina re-enacts her search for her mother in her performances—her search for a loving mother. However, *that* mother is nowhere to be found. Marina will never find her, because this mother refuses to have a relationship with her; this mother is envious; this mother fills herself with her daughter. "It was as if she were me." The dream illustrates that this mother will spare no effort to take control of Marina and drag her into her madness and down into her envy. The re-enactment of violence in all Marina's performances is not least a quest to find a non-violent mother.

The fact that Marina responds to my question about whether she recognizes and enjoys her success with the wish that her mother might be happy and proud—"I'd have loved my mother to have seen Robert Wilson's play"—gives some indication of the unbelievable violence of not being acknowledged and of her mother's disregard. The wall of

disregard can smash some people to pieces. How is Marina supposed to enjoy and savour her success when the only reaction she knows is disregard and a refusal to acknowledge her? Disregard is envy, and it hurts. Marina is afraid of this envy. She herself doesn't mention it, knowing from experience that it is not to be mentioned, and that everyone around her backs this lethal violence, including her father. He didn't take her with him when he left his wife. Envy is not part of Marina's emotional or oral vocabulary. Envy is expressed through her fear of it, and this fear underpins her performances, along with the extremely dangerous lack of care she experienced.

Everything we have so far learnt about the mother testifies to violence. I deem this twisted form of violence crueller than Marina's being beaten and pulled to the floor by her hair. That violence remains unspoken and invisible, only manifesting itself in the pain of her performances—the pain of envy, and the fear of that envy transposed into pain. As spectators, we do not see this pain, and it goes without saying that we too will disregard it, for that is how it has always been. We will acknowledge her achievement in making herself available as a screen onto which 1,545 people could project their thoughts. We will acknowledge her achievement in having persevered in front of 850,000 onlookers. We will acknowledge that Marina withstands violence—violence against herself.

In line with her previous experiences, Marina channels this violence to make it controllable and bearable, as this way at least it is in her own hands. She can decide when it begins and when it ends, as well as where it takes place, namely in the ego, against which the violence is always turned. This way she gains power and control over the violence. From a psychoanalytical perspective this is a sensible approach, although the aim of psychoanalysis is always to render innocence both imaginable and feasible. In addition, Marina attributes a transcendent meaning to violence in her later performances, saying that doing violence to herself enables her to attain a higher state of being. This is a persuasive manner of ascribing meaning and purpose to violence in order to make it bearable. It is easier to endure pain if it is meaningful. Fundamentally, however, violence and pain can never produce meaning.

# No

MA        I never felt any aggression. I can't remember any. In the boat, for example. I was lying on the bottom of the boat and I was simply exhausted. I was bitterly disappointed and hurt. I was everything, you see? And I was so happy to have survived and still be alive.

Psychoanalysis distinguishes between *constructive aggression—aggression to protect the ego—*and *destructive aggression,* which destroys and annihilates. We can all choose between these two possibilities. When Marina says that she never felt any aggression, this is only half the truth. She feels aggression, a great deal of aggression even, but in her performances, she only ever turns it on herself. In her early career, the risk that this aggression might kill her was part and parcel of the performance. Later, dying was no longer an integral feature of the performance; it was far more about enduring and overcoming the impotence and fear produced by violence

so that she wouldn't perish or go mad. Her happiness came from having over*powered* violence, and her joy was due to the temporary release from fear and guilt.

When Marina says that she doesn't feel aggressive, that means that she doesn't regard the violence she turns on herself as aggression. It is true that she doesn't feel *destructive aggression*. The woman we know has no feelings of envy or hatred, no evil intentions or destructive objectives—only towards herself. This demonstrates yet again that violence is normal and inevitable for Marina. She doesn't question it. Yet she is not allowed to harness her *constructive* aggression (the aggression that we all have within us to defend and assert ourselves) and say no in order to protect her ego. A "no" is a "yes" to oneself. We formulate a "no" to protect our well-being and our freedom. If, for some reason, we are unable to do this, we can assume that some authority other than ourselves is trying to take control of us or has already done so. That causes fear, and fear causes impotence. Fear is purely a reaction to the confiscation of our *aggression to protect our ego*. Marina tries to make her life bearable without constructive aggression, to cope without this "no", to survive without this "no", to open up to hundreds of thousands of spectators, to give *everything*, to practise saying "yes". Saying a big "yes" to everyone is saying a big "no" to oneself. That is Marina's story.

*This is what Marina Abramović's performance*
*is about: saying yes to others is saying no to herself.*

MA      Now I say no to a lot of things. I was always so
scared of being alone that I kept working, because when I
wasn't working I felt alone.

For Marina "no" means loneliness. From that I con-
clude that her "no" is punished with exclusion from
a relationship. Loneliness means exclusion from a
vital relationship such as the one with her mother.
So, Marina says "yes" and continues to work tire-
lessly, defending her autonomy and freedom of
choice, and protecting herself from loneliness.
Marina has no experience of a relationship that in-
cludes the possibility of saying "no". This creates a
dilemma, for either she says "yes" to everything ex-
pected of her and is therefore forced to sacrifice her-
self, or she says "no" and is deprived of the relation-
ship. Her brilliant concept for *Untitled* conveys the
misery of this inescapable situation.

Loneliness is fundamentally different from being
alone. *Being alone* is not accompanied by feelings of
loneliness, impotence and crushing emptiness. Being
alone means that there is *somebody* who isn't cur-
rently here. Loneliness, on the other hand, means
that there is *nobody*, even if the person is here. Refus-
ing this "no" within a relationship constitutes vio-
lence and abuse, because it forecloses the aggression

that protects the ego. This has a destructive and devastating effect on Marina's self, and it consigns her to loneliness.

MA     I have always felt responsible for everyone else. I can't do it any longer. My health is ruined.

All visitors to *Rhythm 0* are entitled to do what they want to her, including killing her. Part of her performance is to relieve visitors of their responsibility. It says in the catalogue: "During this period (6 hours) I take full responsibility." This performance provides an insight into an inescapably brutal situation: Marina doesn't know whether she will be killed during those six hours, meaning that she must fear for her life. At the same time, she takes full responsibility for the events, up to and including the possibility of death. This means that a murderer would be exonerated from all guilt. It is a radical and brilliant artistic representation of a relationship, the kind of relationship she knows from experience. Taking responsibility for someone else's behaviour was her only way of establishing and maintaining her relationships with her mother, Ulay and Paolo. Her loneliness—i.e. the rejection—is more unbearable than violence and the fear of violence. By taking responsibility Marina was able to safeguard the relationship.

MA     What happens to people if I say "no", if I push them away?

Marina's first reaction is concern for others. What will happen to *them* if I don't meet their wishes? Will they be okay? Will they feel rejected? She must take responsibility for other people's feelings. That is because her mother turns away and uses Marina's sense of guilt to make her obedient. To force her to stay with her. To make Marina identical to her. To devalue her potential. To no longer have to be envious of a daughter who is reduced to a duplicate of her mother, wearing her mother's clothes. And with a bullet and a pistol in her pockets with which to erase all that remains of her ego. That is the meaning of *Untitled*—loneliness, and nothing more.

This is what Marina Abramović's performance is about: the repetition of loneliness.

Constrained by her mother's clothes, the child is rendered speechless and impotent. She is fearful and panicky. Out of self-preservation she retreats into physical immobility. She tries to eliminate her "no" beyond all recognition by celebrating "yes". She invents *The Artist is Present/Mission Impossible* in 2010 and withdraws into motionlessness for over 700 hours. It makes her world-famous.

This is what Marina Abramović's performance is about: by not moving she moves the world.

My work is the key to my psyche.

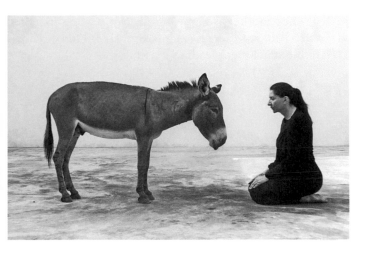

The agony she endures should be understood as a punishment—a punishment for Marina's unwillingness to relinquish her clothes any more, a penance to atone for the guilt she feels towards the other. A debt that isn't hers, because being indebted to one's mother is abuse, and because being indebted to Paolo or Ulay is exploitation. This kind of culpable attachment leads to loneliness.

# Fear and impotence turn to pain

Fear is a central theme of all Marina's performances. Fear is a response to violence. Marina will not mention this fear, just as she doesn't mention violence; she will bear and endure it alone. If the "no" is denied, and the energy of *aggression to protect the ego* blocked, the results are constant and inevitable fear and impotence. Marina's performances are a re-enactment of impotence and fear. She sits alone on the chair in *The Artist is Present/Mission Impossible*, standing and withstanding the pain alone. Nobody gives her water or comfort. She transforms fear and impotence into pain. She transforms motionless impotence into moving pain. The only thing alive in impotence and fear is pain. The only thing alive in impotence and fear is violence towards oneself. This is Marina's technique for converting unbearable impotence and fear into something she can bear.

This is what Marina Abramović's performance is about: converting fear and impotence into something bearable.

Marina can relieve her fear, her mortal fear, by transforming it into pain and staging it over and over again so that she can put it behind her, so that she can feel what its like to be free of it. She immerses herself in the pain and experiences, over and over again, that she has survived. She works away at it and through it. This is Marina's attempt to come to terms with fear, with her experience of mortal fear. The violence that causes this mortal fear goes unchallenged, and the aggressor remains blameless.

For Marina, a relationship means taking responsibility for someone else's life. And the same is true of the other person's death. A relationship means feeling indebted to the other person. Marina grew up with this burden. If she didn't take responsibility she was guilty, or she owes it to the other person to take responsibility for him or her. We must imagine Marina's growing up as part of this equation. Being independent means ceasing to be available for other people. When her mother, Ulay and Paolo refuse to take responsibility for their own lives, they shackle Marina to this duty, and if she doesn't take responsibility for them, she is imputed with guilt. This mechanism can extend to regarding a colleague's possible death, or even suicide, as her responsibility too.

MA      I think that I'm gradually regaining confidence that I won't sink and die if I stop swimming. I've understood that I re-enact that swimming in my performances to prove to myself and to others that I'm not sinking. So, let's not die, but let's stop swimming!

She does, however, have one more, not insignificant reason to keep swimming:

MA      I was so happy to have survived and to be alive. Do you understand? Simply happy to have survived.

Surviving *Mission Impossible*, coming through the pain and achieving worldwide fame, relaxing in the boat: all of these can only be temporary. The moment of happiness and safety is brief and will come to an abrupt end. Marina says, "I always thought that if I did something nice or if I felt good I would be punished. I thought that happiness leads to disaster." This is the only cycle Marina knows, as envy always intervenes, destroying her happiness. For example, the curator of *The Artist is Present* exhibition and performance at MoMA, Klaus Biesenbach, interrupted the performance eight minutes before it was scheduled to end, thus ensuring that most attention was focused on him. She immediately invents the next performance as a means of punishing herself for her fabulous success and achievements, as a form of penance that deprives her of so many natural, vital needs. In the next performance, she will order herself

to put on the shackles again until she is a mere screen onto which others can project their desires, allowing them to see their own large, powerful reflections in her "smallness".

This is what Marina Abramović's performance is about: she serves the sentence for her success.

Yet this next performance is a success too. Marina has incorporated and transformed her dilemma into art. She makes herself available, first to her mother, later to Ulay and then to Paolo, and always to the public. Emptying herself to placate others, reward them and fill them so that they stay with her and do not abandon her: that is how Marina protects herself from annihilating envy.

These are the smart and sensible arrangements by which a creative psyche turns on itself the aggression it receives in order to control it and determine its place and time and duration, making it possible to survive; converting the impotence of the response to violence into pain so that it can be expressed rather than disappearing into the void. These are all signs of an extraordinarily vigorous and creative mind. The fact that Marina has re-enacted the violence throughout her life clearly demonstrates that she knows no other way. She knows only the violence of being punished for living her life and being independent. She knows only one truth: swim or die.

Living means standing on the edge of the precipice, standing on the brink of death. Living means loneliness. Living means being locked in a continual battle with death.

MA     And you know, it makes me sick; it disgusts me. The way I deal with emotions and with the two great loves of my life is *to hurt myself* until I can no longer feel anything. Until I'm numb. I find that a very interesting point. The fact that I actually go so far until it hurts so much that I no longer feel anything. It's strange, inflicting that kind of pain. I have to go right to the end, and the end is where the pain is unbearable and I no longer feel anything. If you cut your leg in a car accident and the nerves are so… I mean the pain is so great that the nerves no longer carry the pain to the brain, you feel nothing and it's as if you'd been amputated. Something like that. So, it's a very serious matter, because it's not just about swimming and surviving, but about deliberately causing so much pain and getting into all these emotions to reach the point at which there are no more emotions. And I've had enough of that. I don't want to suffer any more. It's over!

The attempt to deaden one's feelings is understandable and, in principle, smart. If one is not allowed to defend oneself, what is one supposed to do with all the feelings that arise, such as hatred and anger, in response to those who are the cause of one's suffering? The only possible path is to turn these feelings on oneself. At the same time the idea is to destroy these

feelings, annihilate them until they no longer exist, until they have been amputated. That is because these feelings are not permissible, because they are bad and because these emotions would only land Marina in even greater trouble—making herself guilty by her "no", by her anger and her hatred. Marina is therefore prevented from doing the only obvious thing, which would be to tell those who cause her pain to go to hell.

MA     Paolo left me, but when *The Artist is Present* was a great success at MoMA a year later, he came back. He pretended he wasn't well. He managed to make me feel guilty. He was in such a bad state, he said. He'd left me because I had always been so busy and hadn't had enough time for him, and I was the problem in our marriage. The whole time, he was cheating on me with another woman. It was unbelievable. Another thing: because he was in such a bad state, I gave him money so that he could "find himself", as he put it. I later found out that he'd spent it with that woman.

Paolo staged the suffering inflicted by Marina. He blamed her for his feelings and for their marital break-up. It is always easier to accuse the other person than to take responsibility for oneself.

# Reliable rejection

# Envy

Marina's success is contaminated with guilt and with the fear of this guilt. Her mother employed the technique of playing the victim, and Ulay and Paolo did likewise. Envy is suffering induced by another person's success.[10] What possibilities does someone have to escape guilt when she is entangled in such guilt-riddled relationships?
– Let her counterpart share in her success.
*This panders to envy.*
– Suffer from her own success and refuse to enjoy it.
*This panders to envy.*
– Reduce the success that causes the other person to "suffer".
*This panders to envy.*
– Fund the other person with the money from her success.
*This panders to envy.*

The lethal envy exuded by Marina's mother, Paolo and Ulay as they act out their victimhood lays the blame on Marina. That is her mortal fear: fear of this guilt and this lethal envy. Her every performance is about resisting this mortal fear. On this Marina says, "At that moment it was clear that I had to face up to my fears, and that runs through all my work. In the *Rhythm 0* performance, I put a pistol on the table and took a risk of being killed by the public. I decided to tempt fate and I'm still alive."

A fear of being guilty for other people's death and suffering diminishes one's own vitality. Marina's identification with this guilt is the inevitable consequence of decades of experience. In order to protect the other person from "her" aggression, she will prophylactically train it on herself, in the hope of being spared from guilt.

This is what Marina Abramović's performance is about: doing penance.

Her earlier performances, though extremely brutal, were nevertheless less violent than her more recent ones. First, the possibility of death and then impotence were integral parts of the performance: a cathartic death, then liberating, physical impotence. *The Artist is Present/Mission Impossible* excludes these two possibilities, increasing the agony and its attendant loneliness. In this performance, Marina is

searching for a new escape route, and it becomes a door-opener, with pain as its precondition. Marina says, "My whole body became a receptor and emitter of energy. Due to the long duration, you go through a process and then you reach a higher level, a different state. Pain is a door, and without it you can't get there. You are no longer scared of pain afterwards. The pain disappears."

Marina doesn't challenge the cause of her pain, and since its perpetrators were able to disguise and conceal themselves as "innocent victims", she looks for them in vain. This only serves to make the whole situation more baffling and far more destructive. Acting the innocent, harmless victim is an especially cruel weapon, because it is supposedly free from aggression: envy is suffering induced by another person's success. Marina's mother, Paolo and Ulay all blame her: that is the stuff of which envy is made.

# Incision

In a given space

Performance

Ulay: I am fixed to the wall by a stretched
rubber cord. I move repeatedly towards
the audience as far as the elasticity of the
material permits.

Marina: I am standing parallel to the point
of maximum expansion. A person from
the audience attacks me and leaves. I come
back to my place.

Duration: 30 minutes
April 1978
Galerie H-Humanic, Graz, Austria
Visitors: 200

In the first part of this performance the
public built up aggression towards my
passive role. In the same time, I was expec-
ting an attack from the public, but I didn't
know when.
After the attack, I came back to the same
position as before, but everything had
changed. After the performance, the public
was engaged in an intense discussion about
the function of the observer and his limits.

I believe there's something good in everyone.

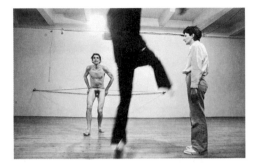

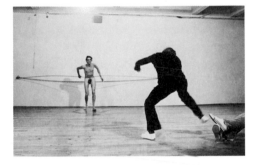

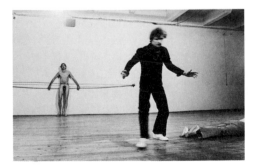

Marina's passive, harmless and innocent position in this performance—she just stands there doing nothing, nothing bad, nothing at all—arouses aggression among the public, and a stranger knocks her to the floor. It is a brilliant performance. It shows innocence, embodied by Marina. It shows an inescapable situation, embodied by Ulay. It shows violence and aggression, embodied by the attacking stranger. Finally, it is the portrayal of a relationship, with the dynamics of this relationship divided between three people: the immanent aggression (in Marina) towards an "innocent sufferer" is taken on by a stranger and expressed visibly and tangibly in the kick with which he knocks her to the floor.

*Incision* is the performance that finally stirred me to speak to Marina. With extraordinary accuracy, she displayed what psychoanalysis does: she makes violence visible. Yet where the violence wishes to remain invisible, it does so. In her *Incision* performance, Marina remains an innocent victim, and a different person, a visitor, takes on the aggression. He knocks Marina to the floor, and he becomes guilty. What is significant is that it is someone else who expresses the aggression that is actually inherent to the "innocent victim". This type of violence is unrivalled in its effectiveness. It is precisely because the "victim position" can displace aggression and define someone else as being violent that it has become a popular and common method. We must ask ourselves why

no visitor tries to release Ulay from his bonds, but knocks Marina down instead, and why violence seems a more obvious response than freeing Ulay. It is a brilliant, inspired performance. Marina shows the paths that violence takes and where it manifests itself, far from the perpetrator, while the perpetrator himself remains blameless.

She is re-enacting her relationship with her mother, who was able to portray herself as a victim through-out her life and displaced her aggression and her envy on her daughter, defining Marina as a perpe-trator of violence against her. This leaves one speechless and numb. Violence cannot be located in its rightful place as long as the pain is silent. If there is no such place, then one cannot see the violence, and its causes cannot be challenged.

This is what Marina Abramović's performance is about: violence is the bass line of all Marina's performances, and it is always kept silent.

This silence lies like a veil over the violence, making it unrecognizable. The systematic repetition of si-lence in Marina's performances allows us to perceive her loneliness, for the violence is never explained and she is never released from her suffering. She is prevented from experiencing what it is like to be innocent.

MA     My brother arrived at my mother's funeral an hour late and totally drunk. She left him everything, but it was me who had looked after her. I paid for two nurses, an apartment, and everything else you can think of. My brother lived around the corner and he never looked after her. There, that's what I got in life.

> *Envy is suffering induced by another person's success.* Her mother's envy towards her successful daughter is apparent in this gesture of disinheritance. The mother doesn't acknowledge her daughter, not even on her deathbed. Here, at death's door, it was still possible to make an about-turn and bring about a rapprochement with her daughter, but Marina's mother rejected her one last time. Disregard had been her mother's prevailing attitude towards her during her lifetime, and the deathbed was the scene of one final re-enactment of the same old envy. We understand even better why this daughter kept trying to win her mother's favour and love, while her mother's response, until the very last moment, was envy manifested as disregard.

This is what Marina Abramović's performance is about: enduring disregard.

JF     There is somebody to whom you are nobody.

MA     Wow, yes. That's fear, terrible fear. There is somebody to whom I am nobody.

Marina manages in her art to perform this situation of annihilation and by doing so regains her identity. She performs the annihilation of her own mobility, her speech, her needs and wishes and her well-being, and achieves worldwide fame. Now people see her! When Marina says that she did everything for her mother, organizing and paying for nurses and much more besides, then we can understand the distress of a daughter who gives *everything* and *receives nothing*, not even the inheritance to which she is legally entitled.

This is what Marina Abramović's performance is about: the unconscious hope that it may turn out differently this time.

She craves recognition as a person with her own identity and her own needs, as a separate person, not recognition for resigning and relinquishing her ego: "I don't want any more relationships in which you take out your own core, your own centre, and put it into the centre of someone else."

I wish to refer back to the aforementioned psycho-analytic term of the self-object relationship, which perfectly describes this process. Marina became the object of her mother, who manipulated her for her own purposes. If Marina fulfilled these purposes, she was rewarded with recognition for her role. However, beyond that role, as a person, Marina

encountered only her mother's disregard and envy. That experience was repeated in her romantic relationships. One's first intensive loving relationship in life is with one's mother, yet mothers respond in different ways, and Marina was treated with disregard. It is impossible for a child to unmask disregard as envy. It will blame itself for the lack of affection and try to do better. This is how an envious mother ensures that a child has to keep trying, in vain.

A child cannot extract itself from this cycle of guilt: it requires an adult to confirm the child's innocence. No adult helped Marina, as her father had failed in his task, leaving her alone with her mother's envy. She attempted to defuse it by seeking to satisfy her mother's needs, especially because this bore fruit: her mother smiled at her. Marina noticed that her mother was conciliatory if she was prepared to give up her own ego. All of us repeat our experiences of our first love relationship with our mothers in all our subsequent relationships of similar intensity, i.e. with our partners.

MA     The only person I wanted to love me, abandoned me. Paolo left me a year before the performance *The Artist is Present*. My pain was indescribable. He stood behind me during the performance of *The Artist is Present* and never came forward. Then, at the highpoint of my career after *The Artist is Present*, he came back. I repeated the same pain. I went into it knowing it was wrong. I should never have

taken him back, because he was the same as he'd been before, maybe even worse. I didn't want to be alone so I took him back. For a year. It is also very interesting that when he's interviewed he says, "My wife, Marina Abramović." That's his identity.

JF     If you could redirect your aggression to where it truly belongs—towards your late mother and Ulay and Paolo—then it would no longer be directed at yourself.

MA     The pain when Paolo left me was devastating. When I came to see you, I thought he wasn't in a good state. He kept saying to me that I made him suffer. Actually he was already having an affair, but I only found that out much later.

JF     It is envy that destroys.

MA     I've just completed a three-day workshop (August 2015). I didn't do the same hardcore thing as usual. We always used to put ourselves through hell, but not this time. Everything was different. We had time, we worked, we relaxed; it turned into such a wonderful thing. I wasn't capable of admitting that the easy way is good too. Why do I let myself do that now? That's what I'd like to know. I always took the hard way. Is it because I'm getting old? I'm still pretty fit, though. That isn't the reason—I can cope. Why do I see now that the easy way is okay? I never saw it as an option. I never let myself.

JF     Imagine that hell is gone. Imagine that the pain is gone, and imagine that fear is gone too. Imagine that enjoyment becomes an essential part of your life. Then the accumulated nastiness of all your "loved ones" comes to the fore: they will burst with envy. You were so scared of that envy that you placated and appeased the evil spirits in advance by saying, "Just look at my hardcore thing! This is my punishment for having so much success!" Which was pretty sensible, because the hardcore thing shielded you from so much envy.

This is what Marina Abramović's performance is about: pre-emptive suffering placated the evil, envious spirits.

Her father was emotionally absent and didn't free her from the lethal clutches of her envious, nasty (step)mother, so she waited for a prince to take on this role. Many women today are still waiting for their prince: to survive the lethal envy safely in his protection, to not run the risk of cutting out a hunter's heart. Here too Marina's father failed: he exposed her to her mother's envy.

I've had enough.

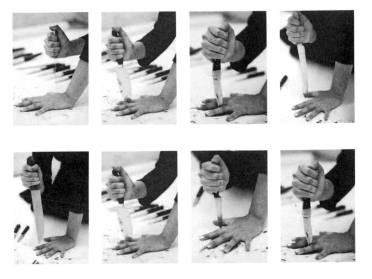

I don't want to suffer anymore.

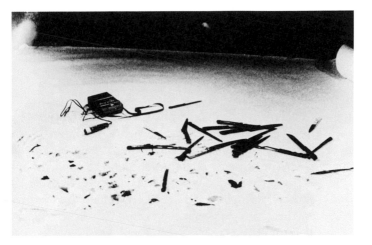

# Doorknob

MA    There was this one occasion that completely threw me. A woman attending the performance *512 Hours* in the Serpentine Gallery (London 2014) came up to me. She was angry when she arrived, and when she left she was even angrier, so I asked her if she wanted to talk to me. She said, "I don't want to talk to you. I don't like you." I was so unprepared for this that I couldn't stop crying. It was so strange. Why did I react that way?

JF    It was impossible for you to say or even think, "Leave me alone, you stupid cow." Because you're used to giving *everything*, even your *aggression to protect the ego* and the possibility of putting up a fight. What was demanded of you was to be open for everything, to let go of the doorknob, so that you would be helplessly exposed to all kinds of nastiness. All you can do is to weep desperately.

MA    But do you know why? That's the really important thing. Because I believe there's some goodness in everyone.

And if you ask me why I don't have that *aggression to protect my ego*, then it's because I believe in goodness, and also because there's always a reason why people do one thing or another.

JF        There may be some goodness in everybody. Only God above knows that, we don't. But as long as we're here on Earth and not up in heaven, as long as somebody is being nasty to you, you are entitled and obliged to stand up for yourself and defend yourself. You cannot excuse another person's aggression and look for his kind core while he's beating you up. You take the sting out of his aggression and tolerate it. In other words, you legitimize violence; you authorize violence against yourself.

The energy we have to protect our ego and defend ourselves is absolutely vital. We all have it; the only question is whether we are allowed to use it, if we can employ it without guilt to protect ourselves Marina has no possibility of using hers. She *has* to be good. She *has* to give *everything*. She has to be open to everyone, whether they wish her good or ill.

This is what Marina Abramović's performance is about: the search for her mother's core goodness.

Marina never stops searching for the good core of love, a mother's love for her daughter. With each performance, she gives her mother—even though she is long dead—another chance to be good inside

and to be good to her daughter; to love her, to accept her as she is, and to be proud of Marina. That would release Marina from her guilt: "I never knew what I'd done wrong." She would be released from the agony of suffering because she would realize that she is not the one making her mother, Ulay or Paolo suffer. It's the other way around: suffering was inflicted on *her* by loading her with guilt.

MA    When I moved, I bought a loft in New York. Below me lived a filmmaker who was at war with the entire world. He was constantly writing me letters, accusing me of jumping around in the middle of the night, although I was asleep, because the floor was so unstable, then because of the elevator, and so on. He accused me of all kinds of things. Everybody knew what he was like. Christmas came, and I bought a bottle of champagne and a box of French chocolates. I rang his doorbell. He opened the door and asked, "What do you want?" I said, "Merry Christmas!" He looked at me and shut the door. It didn't change him, and he kept on behaving exactly the same. Every Christmas for five years, I took him champagne and chocolates. The sixth year he rang my doorbell because he wanted to give me Goya's biography and some flowers, but I wasn't at home, and he wrote that he'd missed me. When I moved out after my separation, he said, "I'm so sad now that you're not here any longer." He died about two years later of throat cancer. Unbelievable. Five years. I couldn't deal with his aggression. I had to find out why he was the way he was and change it. At that moment when he rang my doorbell and wanted to give me the book,

those five years had all been worth it. Well, why do I have to do that? Why don't I have any choice, as you say? What would my aggression to protect my ego do for him? Wouldn't it just feed his aggression? There's a saying by the Dalai Lama that I find very important: "Only if we learn to forgive can we stop killing." That was always relevant for me.

JF     The others must ask for forgiveness, not you. You mustn't forgive them and, what's more, justify their behaviour, if they don't request your forgiveness.

MA     Hold on, hold on. That is a completely new idea to me. I cannot forgive somebody for free. What happens if one does forgive somebody unconditionally? I do that all the time.

JF     If you forgive somebody without being asked, you bear the pain. You bear it all alone.

MA     That's right. You forgive, but at the same time there's pain. If you forgive someone for nothing, you are alone with your pain. That is really important for me. But if you are asked for forgiveness. So you have to be asked. What happens if I forgive someone for free is that I'm back swimming towards my father without saying anything. If I forgive for free, it's like always reaching land without saying to my father, "You asshole!" And the pain of being abandoned and being alone never goes away. You mean I should really say, "Go to hell!" and really get angry?

JF     Yes, I do. Then you will be free of pain and protected.

MA     I am so tired of it all. I just want to be me, the real me, not the one other people want me to be.

JF     Then you shouldn't put up with five years of aggression from your neighbour, spend money on chocolates and champagne, make an effort for him, knock on doors and have them slammed in your face—all for a smile. The price is really too high.

Buttering people up
doesn't still
their hunger

## Love

MA     Can we talk about love? I have no shame when it comes to love: I give everything, and the more I give, the more pain is inflicted on me at the end. For me love is like my performances: I give *everything*. I give simply everything, without calculations or plans. All or nothing. Unfortunately, I haven't been able to find anyone who operates the same way—that is, completely honestly, not based on a lie. Maybe for a short time, but then it was gone. Why do I have such a strong need for love?

JF     We all need to be loved. It's normal. For you love means the dissolution of your self, giving everything to the point of motionless and abnegation. We can see that from your performances.

> This is what Marina Abramović's performance is about: the search for love.

JF     You've never received any love for your vitality, your strength, your wishes and needs. You've never been given room in a relationship, only abnegation and the pain of that abnegation. You have learnt to turn that abnegation into something positive, because you know no alternative. Recognition is love. You have received recognition for your abnegation. Worldwide recognition.

The inescapability of this abnegation is a sign of violence, yet Marina can use it to defuse her mother's envy and that of her two partners, Ulay and Paolo. It says: If I have nothing left, then you can't take anything more away from me. If I've already given you everything, then there's nothing left for you to take. I'm giving it to you voluntarily because you're going to take it from me anyway, and it's less devastating if I do it myself.

This is what Marina Abramović's performance is about: abnegation protects you from envy.

It is therefore not Marina's need for love, which she assumes is too strong, that is necessary here, but *aggression to protect the ego*: "You don't love me enough, so leave me alone!"

MA     Oh my God. So you don't put yourself in a position of suffering, in the position of being grateful for little. That's what happened to me with Paolo. I was grateful for very little, because a very little is better than nothing. *Better*

*little than nothing*—I should write that down. To not be sat-
isfied with little you have to get angry. Not be submissive,
just I want more! Why do I prefer a little to nothing?

JF     It is unbearable to keep coming up against *nothing*.
It's terrible. There is somebody to whom I am nobody.
Your mother punished you by withdrawing her affection
and turning away from you. You take a little so as not to
slam into this *nothing* and going mad. That's sensible. A little
smile is better than *nothing*.

> I answer Marina's question "Why do I prefer a little
> to nothing?" by praising her for having found an
> extremely skilful and creative way of escaping the
> void, of clinging onto a tiny little bit, so that she can
> at least save this tiny little bit from the void and its
> devastating meaninglessness.

> This is what Marina Abramović's performance
> is about: emptying herself to escape the void.

> If Marina retains her own fullness, she will be
> struck with envy, and the punishment for having so
> much success will be swift and cruel. Her mother
> beat her and threw her to the floor by her hair, pun-
> ishing her with disregard and guilt. This was then
> repeated in her subsequent romantic relationships.
> Marina owes the others her fullness; that was how
> she grew up. Otherwise she is *to blame*. That is the
> way her mother talked to her, and that is the way

Ulay and Paolo talked to her. Marina must atone for this guilt. She has no choice: either she is cast into the devastating void, or she has to make do with only a little. She acted sensibly in the circumstances, but having to grow up with this dilemma was an act of violence against Marina, and that should not be forgotten.

MA What happens the moment I end a relationship that is doing me no good? I know I won't sink, but I will be alone. What then?

JF Only until a man comes along who meets your fullness with his fullness, not his emptiness! Someone who doesn't need to be fed, because he is responsible for feeding himself. That is the greatest difference from how you were brought up. You learned to empty yourself so that the other person would love you. You weren't allowed to enjoy your own fullness.

MA But the moment I accept my fullness, the other person is hurt and feels rejected, and I feel incredibly guilty. I feel guilty for having more than the other person, and I level it out. So I always tried to make them (Ulay and Paolo) equal with me so I didn't get punished emotionally. They punished me emotionally for not being equal.

JF By levelling things out you can keep their envy in check because they will gain from you, and at the same time you can calm your own sense of guilt because you let them

be part of you. That is a wise and sensible move in the cir-
cumstances.

> This is what Marina Abramović's performance
> is about: she works away at the guilt.

Marina's fullness comes from her satisfaction at hav-
ing made other people happy, and her contentment
from having made others contented and having
shed her guilt. Marina fills herself with the recogni-
tion she receives for having emptied herself, and
with the confirmation that the other person will
leave full. As she is there for them, she will have
their undivided attention at that precise moment.
Marina has never received this kind of attention and
responsibility herself. She is willing to give this to
everyone and to give herself: "I can't deprive others
of me—it will kill them." That was how she made
her mother happy, as well as being a good mother to
her mother: "If I received even a very little, that
was already like a ray of sunlight." Elsewhere Mari-
na says, "I was so happy to have survived and to still
be alive." If you are so glad to have survived and not
be dead, then the relief at this new lease of life is so
overwhelming that the question of who put Marina
in that life-threatening situation in the first place
goes unasked. Relief swallows up all questions as to
the perpetrator.

Ultimately, therefore, the performance does not solve this conundrum because the conundrum does not even appear to exist, given that the secret is hidden and unspoken. No attention is paid to the matter of violence and who is responsible for the violence. The performance is the re-enactment of her suffering and pain. Marina re-enacts them because all alternatives are denied to her, and because this way she can keep proving that she is capable of enduring and surviving them. The performance is a process of working away at the guilt and is therefore accompanied by great suffering.

I always took the hard way.

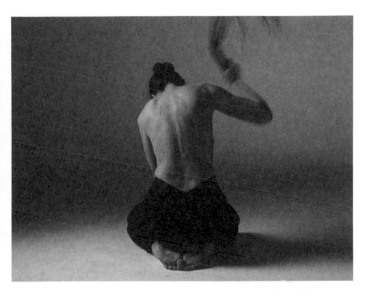

I never saw taking the easy way as an option.

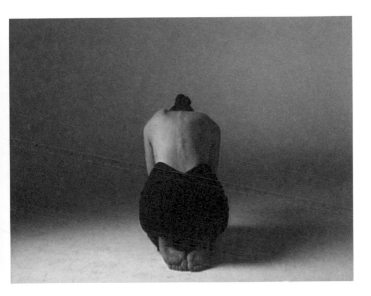

# 0 : 1

MA    I have an incredible story to tell. There was this
young Asian woman who came very early in the morning,
right after MoMA opened, and she sat with me with a small
child wearing a hat. It was asleep in her arms, a baby. She
looked at me, and I've never seen anything sadder in my
whole life. She sat with me for an hour and at some point
she slowly removed the hat from the child's head. It was
shaved, and there was a scar running across its scalp. Then
she looked at me, put the hat back on and left. It was such a
sad moment. The photographer, Marco Anelli, took pic-
tures of every person who sat down with me, which meant
that he was there for exactly the same length of time as I
was. He couldn't go to the toilet or eat anything either. It
was crazy. He made a book of those photos. Three months
later I received a letter. She wrote that she was the woman
with the child and she had seen her picture in the book.
Now she wanted to tell me something about her child. "My
baby was born with a brain tumour, and I went to chemo-
therapy every day. It was terrible because she suffered so

badly from the treatment and she was only eight months old. That morning I had just come out of the surgery, where the doctors had told me that they couldn't treat her any more and that she was going to die." She was happy that the child no longer had to suffer, but sad that it spelled the end for her. She came to MoMA to sit with me, then we began corresponding. One day I met her at the theatre and she ran towards me, delighted. She was pregnant again and sent me a photo of her child after it was born.

Looking back at what I've achieved in my life, I started off with four spectators, then it was 20 or 30, and at MoMA it was 850,000. That's an amazing number of people, and I bear a huge responsibility. I almost have the feeling that I shouldn't have a private life any more. A private life excludes everyone else because it is 1:1, making it hard to include others. When Ulay and I sat on two chairs, he occupied that space. When he left, everyone else took over that space. My work is the key to my psyche.

The young woman at MoMA has Marina's full, undivided and non-judgemental attention, which makes her feel that she could open up and show her pain: she removes the hat from her child's head. She shares the pain of her grief with Marina, showing great trust in her. In response to my question of what she thought about during the MoMA performance, Marina says, "Nothing. The idea was simply to be there. With my body and my mind. Every time my thoughts started to drift away, I fetched

them back, back into the moment." Marina describes this as a 1:1 relationship, by which she means that she makes herself completely empty for the person sitting opposite. Afterwards she will be filled with pain, and the young mother will be relieved, just as Marina was later filled with the aggression of the woman attending *512 Hours* who told her, "I don't like you." Filled and alone with it. 1:1 means being empty, unprotected and open for another person's needs, not allowing her thoughts to wander and pull her away so that she can be fully available for the other person—for their anger, their pain, their grief or even their nastiness. That is the form of relationship that Marina has learnt. She must give up herself. Her ego must squeeze itself into the other person's neediness. Everything else must remain outside; she must remain outside. And as soon as she does not produce this abnegation, she is cut her to the quick by other people's envy.

This is what Marina Abramović's performance is about: a 0:1 relationship.

MA    The idea behind my MoMA performance was simply to be there. It's immensely important for me to be in the here and now and nowhere else. Of course sometimes you escape, but I always fetched myself back, because I didn't want that. I was always directly with the person, and sometimes that person's energy was so powerful that I could feel their pain and their suffering.

Marina's own feelings are not worthy of mention and require no attention at all. They fade into insignificance, and she has to eradicate them. Even as a child she learned to take responsibility for her mother's feelings, and she had to arrange her own life around them. The price she pays is exhaustion, a physical reaction of dangerously high blood pressure. "I can't deprive others of me—it will kill them," says Marina. Failing that, it will kill her. Might this be the theme of a future performance: depriving others of herself?

"A private life excludes everyone else," says Marina. Isn't it actually the other way around? Her detractors say that her *success* makes them suffer, and use it to justify punishing her with separation. Paolo also said, "You work so much that you have broken our marriage." A private life excludes nobody, unless the envious person withdraws to exclude Marina from a marriage that could be a place of empowerment and regeneration.

This is what Marina Abramović's performance is about: she transforms her exclusion from goodwill into art.

# Lonely

MA     I've had enough pain and sadness. I want to reduce them to a minimum, as well as the melancholy that is always with me. Explain to me how I can be surrounded by so many people in my life who love me, worship me, and would do so much for me, and yet I feel so lonely, so truly alone. Another matter is that I am so aware of the finiteness of life, of all the things I would still like to achieve and how much time I have left. It isn't dying that scares me: it's the unstoppable passing of time. The older we get the faster time passes. We were young for so long. I give talks to 3,000 people and they want to kiss me and be with me, and I go home and feel alone.

> This is what Marina Abramović's performance
> is about: not being alone, but lonely.

JF     Could it be that it is emotionally risky for you to enjoy your success and worldwide recognition? Really savour it, fill yourself with it, and sit contentedly and satisfied

in the sun? Could it be that the toll you pay to envy is enjoyment, so you deny yourself all enjoyment? To placate your detractors. Could it be that a premature death would cheat you out of time to enjoy your fullness? That your fear is that you won't have enough time to enjoy your own achievements and success?

Enjoyment means being proud of one's work and oneself. In this respect her fear of not having enough time would be a fear of not being able to keep her own work for herself and for her own satisfaction, allowing her to approach old age with confidence. Enjoyment would mean acknowledging that her own work is magnificent, a magnificent achievement and, filled with it, she could grow old. Is accepting her own fullness the emotional risk? No longer giving it away? Keeping it to herself? Might this be a possible theme for a future performance? In my opinion, her fear of missing something in the time she has left is an expression of her fear of missing out on her own fullness and being unable to enjoy it.

MA    Do you know what hurts me the most? My mother was never interested in my true wishes. Not once. And I think that it is my duty on Earth to be there for everyone. I have the feeling that that is my obligation. My mother never hugged or kissed me. She didn't want to spoil me, she later said. The only time I could touch her was when she didn't know it was me, because she had dementia. I didn't trust my

mother, I didn't trust my father to rescue me, so how can I trust anyone else?

JF      It isn't the finiteness of time that makes it hard for you and causes your melancholy. It is the pain of having no interlocutor. There is somebody to whom I am nobody. If you don't keep on swimming, if you don't go on filling, then there's nothing, simply nothing. No relationship, no loving hand, no comfort, no pride. Either you swim, or you look this nothingness in the eye. You see a father you couldn't rely on, a mother you couldn't rely on, and parents who abandoned you. That's very sad, that is your melancholy, coupled with your sense of guilt for not feeling that you're worth it. The only person you can rely on is yourself. Now, when you can no longer swim because your blood pressure is too high and it is too dangerous for your health to swim the whole time, there is a great fear about what happens next. Will I sink? Will everyone abandon me because I no longer feed them? Yes, all your loved ones abandoned you when you didn't feed them any more. Or perhaps you fed them 'wrongly' or 'too little', depending on how arrogant the other person was. That's why your melancholy is the fear you won't have enough time before you sink. Having enough time for you, in *your* boat. Having enough time for that which is dear to you. Without swimming, without feeding. Time exclusively for *yourself*.

You won't sink, you'll see. And once you've seen that, you'll notice that there *is* enough time, because the sinking and the obligations to others will fall away. Because you have given

enough. Because that will do! Because everyone has to take responsibility for themselves, and you will no longer be responsible for them. Only for yourself. For your time in your boat. You can rely on yourself.

This is what Marina Abramović's next performance is about: the great NO.

## Timeless Point of View
p. 1
Ulay/Marina Abramović
Video (colour, sound)
10 minutes
1980
Ijsselmeer/Marken, Holland
© Ulay/Marina Abramović
Courtesy of the Marina Abramović
Archives

## The Artist is Present
pp. 49 / 51 / 53 / 55
Marina Abramović
Performance
3 months
2010
The Museum of Modern Art,
New York, NY
Photo: Marco Anelli
Courtesy of the Marina Abramović
Archives

## Rhythm 0
pp. 21 / 23 / 25
Marina Abramović
Performance
6 hours
1974
Studio Morra, Naples
Photo: Donatelli Sbarra
Courtesy of the Marina Abramović
Archives

## Confession
p. 107
Marina Abramović
Performance for video
60 minutes
2010
© Marina Abramović
Courtesy of the Marina Abramović
Archives

## Untitled
p. 31
Marina Abramović
Performance proposal
Pencil on paper
1970
Galerija Doma Omladine, Belgrade
© Marina Abramović
Courtesy of the Marina Abramović
Archives

## Incision
p. 125
Ulay/Marina Abramović
Performance
30 minutes
1978
Galerie H-Humanic, Graz, Austria
© Ulay/Marina Abramović
Courtesy of the Marina Abramović
Archives

Original idea: Jeannette Fischer and Marina Abramović
Translation: Simon Pare
Copy editing: Bernhard Wenger
Proofreading: Louise Stein
Design: Vera Reifler and Jacqueline Schöb
Cover photo: © Dr. Marc Philip Seidel, vissivo.ch
Printing and binding: Gugler GmbH
Lithography: Michael Liebert

© 2018 Jeannette Fischer and Verlag Scheidegger &
Spiess AG, Zurich

© 2018 ProLitteris, Zurich, for all works by
Marina Abramović

Verlag Scheidegger & Spiess AG
Niederdorfstrasse 54
8001 Zürich
Switzerland

www.scheidegger-spiess.ch

Scheidegger & Spiess is being supported by the Federal
Office of Culture with a general subsidy for the years
2016–2020.

ISBN 978-3-85881-794-5

**Rhythm 10**
pp. 135 / 137
Marina Abramović
Performance
1 hour
1973
Museo d'Arte Contemporanea Villa
Borghese, Rome
© Marina Abramović
Courtesy of the Marina Abramović
Archives

**Dissolution**
pp. 153 / 155
Marina Abramović
1997
From the series Spirit House Perfor-
mance for video, Amsterdam
© Marina Abramović
Courtesy of the Marina Abramović
Archives

**Jeannette Fischer and
Marina Abramović**
p. 165
August 2015 MAI, Hudson
© Marc Philip Seidel, Zurich

1.  * 30.11.1946

2.  Lecture by Dr Bianca Gueye,
psychiatrist and psychoanalyst in
Zurich, 2015

3.  *Rhythm 0*

4.  Ulay is the abbreviated name
of Frank Uwe Laysiepen, born on
30.11.1943 in Solingen, Germany.
Ulay was Marina Abramović's part-
ner in life and art from 1976 to 1988.

5.  Matthew Akers recorded the
exhibition and performance of *The
Artist is Present* in his film of the same
name. It was released in 2012 and
won six awards.

6.  They separated at the end of
their performance *The Lovers*, in
which they walked along the Great
Wall of China. See footnote 4.

7.  Marina Abramović was married
to Paolo Canevari from 2006 to 2009.

8.  Anohni (*1971) is a British
singer-songwriter and video artist.

9.  A play by Robert Wilson and
Marina Abramović. It was first
performed at the 2011 Manchester
International Festival, then on tour
until December 2013.

10.  Ernst Fehr, University of Zurich,
Neue Zürcher Zeitung, Nr 277,
27–28 November 1999.